Expressive Watercolor Techniques

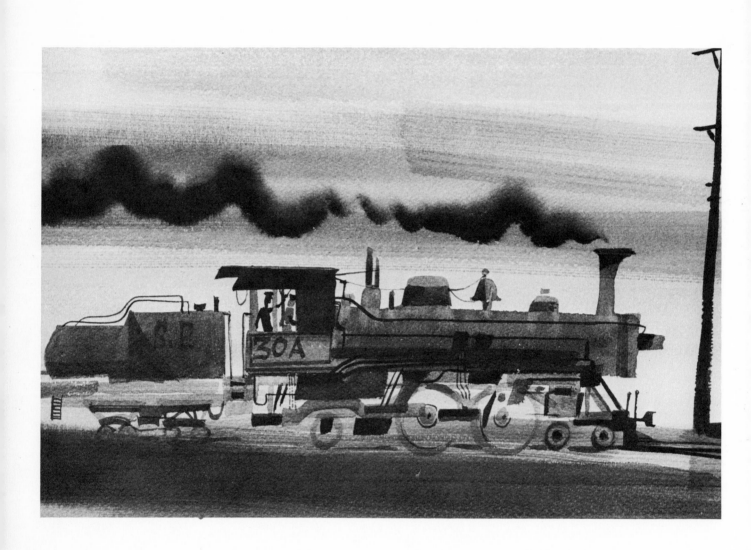

Expressive Watercolor Techniques

Albert W. Porter

Davis Publications, Inc.
Worcester, Massachusetts

To Shirl, Sean, Bill, and Jerry

Also by Albert Porter
The Art of Sketching

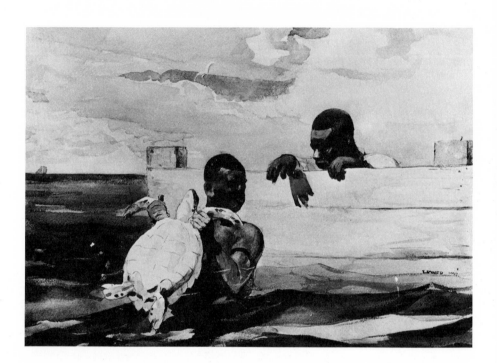

The Turtle Pond, Winslow Homer, courtesy of The Brooklyn Museum. Playing darks against lights is a way to achieve clarity and strength in watercolor.

Copyright 1982

Davis Publications, Inc.
Worcester, Massachusetts, U.S.A.

Printed in the United States of America
Library of Congress Catalog Card Number: 81–70891
ISBN: 0–87192–136–7

Graphic Design: Penny Darras-Maxwell

Unless otherwise noted, studies and paintings are by the author.

10 9 8 7 6 5 4 3 2

Contents

Introduction

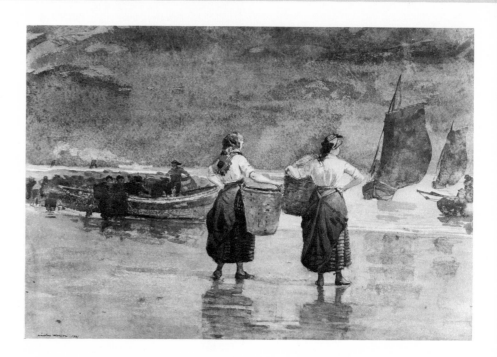

Fisher Girls on the Beach, Tynemouth, 1881, Winslow Homer, courtesy of The Brooklyn Museum Purchase Fund.

William Turner, the famous nineteenth-century English painter, is said to have been painting one evening near the mouth of the Thames while a puzzled observer looked on. In his unique, expressive style, Turner was capturing the sunset as it worked its visual joys over the water. After half-heartedly trying to match the painting with the scene, the onlooker said, "I just don't see colors like those," to which Turner laconically replied, "Don't you wish you could."

This sounds like the perfect squelch, but the truth about this disparity of vision is quite clear: The artist has an inner vision and a visual response that often far outreaches the inner vision of the viewing public. Turner, one of the great innovators in paint, left a legacy of powerful visual imagery and expressive work. His vaporous, evocative moods reach out to the attuned observer with striking communicative force. He expressed ideas, events, and natural phenomena with consummate skill and conviction. The hundreds of watercolors he produced in his lifetime represented a visual breakthrough for a medium that in his time had not been taken seriously, although watercolor has been around since early civilization. Along with Turner there was a host of painters who made watercolor a unique expressive force for graphic interpretation, among them

Charles Burchfield, Mary Cassatt, Paul Cezanne, Charles Demuth, Winslow Homer, Edward Hopper, John Marin, Georgia O'Keefe, John Singer Sargent, Charles Sheeler, Lee Weiss and Andrew Wyeth.

Expressiveness is still a vital concern for watercolorists. This book deals with watercolor not just as an interesting descriptive medium, but more importantly as a means of making our ideas more powerful, more imaginative, and more genuinely convincing. To do this we need to understand how to use the basic skills, materials, and design elements in ways that stir the imagination. Each chapter of the book stresses this theme.

The first chapter looks at basic watercolor materials. Next follows a review of the essential techniques. In the third chapter these techniques are employed in three inventive approaches. Chapters on improvisation, compositional concerns, using color and value, and subject matter treatments explore further means of expression. A look at the intuitive application of watercolor stresses the development of imaginative responses, and the summary points out new directions and challenges.

Watercolor is a natural medium to use for awakening our creativity. Its capability for being pushed in diverse directions kindles the imaginative process. Its perverse qualities (drying irregularities, runbacks, diminishing intensities, testy overglazing) add to our challenge to harness its innate vigor. The paintings that fill these pages prove that watercolor can speak eloquently in many directions. Its artistic potentials seem limitless.

Expressive Watercolor Techniques provides an opportunity to share experiences that have had an impact on my own painting and teaching career. My hope is that this book will engender a refreshing release of creative energy for its readers. As our world changes so will the use of this medium to evoke new imagery compatible with our visual environment. But it will always deal with life's expressive content. The starting point is now, and how our artistic work develops will be affected by our ongoing involvement with paint, brushes, paper, and that most important ingredient, personal expression.

The Materials

Browsing through a well-equipped art store immediately points up the diverse materials available for the watercolor painter. Generally, supplies fall into two categories: those for students and beginners and those for advanced students and professionals. Price and quality are the differentiating factors. Some student-grade paints and relatively inexpensive papers and brushes provide adequate results; but to achieve professional results it is recommended that top-quality supplies be used for your serious efforts.

Papers Watercolor paper is one of the most important items to consider since surface working qualities profoundly affect results. Paper qualities are determined by material composition, manufacturing procedures, weight, and surface conditioning. All-linen rag papers, particularly those imported from England, France, and Italy, have consistently superior surfaces. Several new watercolor papers produced from synthetic materials are quite receptive to most watercolor techniques. You might also try rice paper which is highly absorbent and suited to direct brush work and limited washes. Down the line you'll find machine-made papers, many with fairly pronounced patterned surfaces that dominate the final result. These types of paper are best used for quick studies or practice sheets.

Weight is based on how many pounds of paper are needed for a ream (500 sheets). A medium-weight paper is produced as 140 pounds to the ream or 140-pound weight. Light-weights are around 70 pounds, and heavy papers come in weights of 300 to 400 pounds.

A wide range of paper sizes is sold either in pads, blocks, or single sheets. For many watercolorists buying paper by quires (25 sheets) is a reasonable way of stocking paper supplies. The professional names and standard sizes are: Royal 19" x 24"; super royal 19¼" x 27"; imperial 22" x 30" (most popular); elephant 23" x 28"; double elephant 26½" x 40"; and antiquarian 31" x 53". Larger dimensions can be obtained by buying paper from a roll. The American watercolorist Charles Burchfield at times pieced together large sheets. The thrill of working with large house-painting brushes and a wide expanse of receptive white surface is a creative challenge a watercolorist might just need to start the flow of ideas and expand technical performance.

Paper surfaces control the reflectivity of transparent color, the absorption of paint, and general working qualities. Rough watercolor

paper is an extremely popular choice with painters. The sparkle from whiter top areas of this irregular surface contrasts with the tiny wells of receptive low areas that retain most of the paint. For wet-into-wet and vigorous brush techniques, rough paper is ideal. A slightly flattened surface that gives a relatively smooth quality is called cold-pressed. Because it works efficiently for all techniques and its smooth surface allows for more brush and wash control, it is very popular. Hot-pressed surfaces, such as illustration board, are less receptive to overwashes and reworking and are best used for more carefully structured work.

Most papers are identified with watermarks; some are imprinted with embossed logos. The preferred painting side is the one with the readable watermark or embossment. All rag papers, however, are good on both sides, so disappointments can be reworked on the reverse side. Try a variety of papers and decide on those that give you the most satisfactory results.

All light- and medium-weight papers need to be stretched to provide a consistently taut surface. To stretch the paper, first soak it for a few minutes while cutting one strip of 2″ butcher tape for each side of the paper. Flatten the wet paper on a sufficiently large board and use paper towels to pick up some of the excess water around the edges. Wet a strip of butcher tape with a damp sponge and align the strip over the edge of the paper so that half of the length falls onto the board, and press firmly. Tape the remaining three sides and allow the paper to dry thoroughly before it is used. An alternate method uses a stapler to affix the wet paper to the board. Staples should be placed 1/2″ from the edges of the paper at 2″ intervals. If you suspect that your taped stretch may come loose, consider reinforcing it with staples.

Stretching paper keeps the working surface flat throughout the painting process. Butcher tape or staples hold the paper tight. The plastic board below uses wedges to hold a half sheet of paper taut.

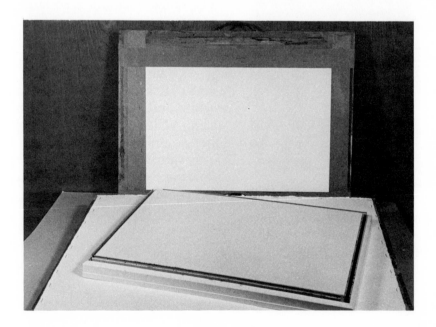

Paints

This may be the toughest area of our material decisions. Paint comes in such a vast array of colors, containers, brands, and grades that choices seem unlimited. It is important to differentiate between opaque and transparent paints. Such opaque paints as acrylic, gouache, designer colors, tempera, and opaque watercolor can be thinned to achieve some degree of transparency. (A number of artists use thinned acrylic paints to approximate the transparent nature of watercolor.) These media, however, are noted for their covering ability and are best used to achieve opaque surfaces. Watercolor pigments are specially manufactured for use on paper as a transparent medium. Check labels to be sure that the paints you choose are designated for watercolor use and avoid any described as opaque.

Watercolor paints are sold in cakes, pans and tubes. Cake and pan colors have to be moistened before use and often require active brushing to pick up the paint. Students often use cakes and pans. Most pan sets are made for young people of preschool and elementary school age; they are inexpensive, self-contained, and portable. Although these sets are usually made up of impermanent paint not intended for professional work, a pan set may be convenient for sketching trips. You may be able to find a set made up of professional grade paint.

Most watercolorists prefer the moist tube paints. Clean paint can be squeezed out to any quantity as needed. When used in a lidded or covered palette, the paint will stay moist and usable for a week or two. Tubes come in several sizes, although #2 (½″ x 2″) and #5 (¾″ x 3″) are the most common. The larger studio-size #5 tube is the best buy for quantity. Student-grade paint is less expensive but it lacks the permanency and rich working qualities of professional quality paint.

The range of colors is so large that making appropriate selections may seem hit or miss. A good rule of thumb is to start with a basic set and add as experience dictates. A cool and a warm pigment for each primary color along with some earth colors provides a good starting palette: cadmium yellow light (cool) and cadmium yellow deep (warm); alizarin crimson (cool) and cadmium red light or vermilion (warm); phthalocyanine or monastral blue (cool) and ultramarine (warm); yellow ochre, burnt sienna, and burnt umber or warm sepia. Other colors well worth adding later on are: new gamboge, a fine, warm staining yellow; orange, to bridge some of those nuances in yellows and reds; thalo or monastral green, another strong staining color; cobalt blue, a light, slightly opaque middle blue; Prussian blue or Antwerp blue, both intense, good mixing blues; Payne's gray, useful for toning down colors or as a cool black. Alizarin crimson, Prussian blue, monastral and thalo colors, and the Winsor hues are powerful staining hues that penetrate the paper's surface and resist washing off. Other colors have more surface sediment and are more easily removed. Some watercolorists also include a black, such as

The term "selected list" refers to permanent colors. Large studio tubes like these are the best buy for quantity.

lamp black or ivory black, used for its own sake, for shading colors, or for black and white sketches. Transparent watercolor dyes provide intense color. Although not permanent, these colors are great for use in sketching and color studies. Their general use in graphic design and illustration attest to the popularity of these brilliant hues.

Palettes

You can mix paint on a china plate, on a butcher's tray, or in any number of commercially produced metal or plastic palettes. The important factors are the size of the mixing wells and the size and number of paint partitions. All surfaces should be white so that color can be accurately judged. Lidded palettes keep paint from drying out, and their lids can be used as extra mixing surfaces. Both metal and plastic lidded palettes serve the watercolorist extremely well.

Be sure to squeeze out adequate amounts of paint so that it can be used generously when needed, and last through an extensive painting session. Add paint when needed and occasionally dampen paint when it appears to be drying out. When not using your palette, cover it with plastic wrap or a lid, and insert a small wet sponge to help retain a moist atmosphere.

Palettes are for mixing paints. Small boxes are good for sketching, but large mixing wells are preferred. Enameled fold-up metal boxes and plastic-lidded palettes are popular.

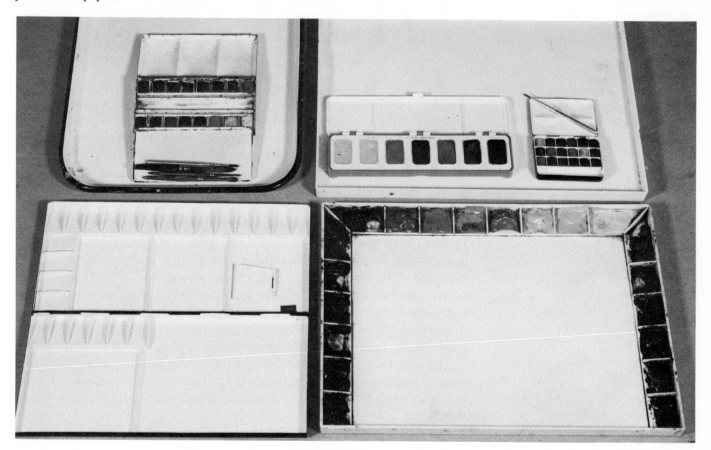

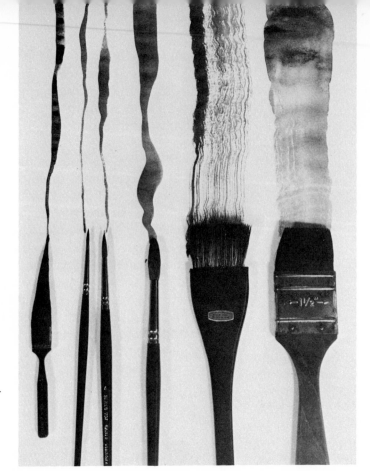

The flexibility of a brush is an important element. Flat brushes are excellent for large washes, while pointed hair brushes give intriguing line variations.

Brushes Pointed hair brushes are the watercolorist's main tools, complemented by flat brushes of both hair and bristle. A pointed brush should be resilient and come to a sharp point. This kind of perfection generally comes from the hair of a Siberian mink called a kolinsky. Its unique hair structure is delicately tapered, creating a slender tip with ultimate flexibility. Brushes made of these hairs are termed red sables. Although their price tag is high, their durability and dependability make them indispensable.

Along with red sable are other acceptable hair types. Ox hair and blends of ox hair and red sable are firm and springy. Camel hair (usually made from squirrel hair) is much softer and considerably less resilient. There are brown and black sables, and white sables are worth investigating as relatively inexpensive brushes. Numerous synthetic brushes also work well. Testing brushes is imperative since quality varies so much. Dip the brush in water and shake it out; a good brush snaps back to a point while a poor one splays or splits.

Three sizes of pointed brushes are sufficient for most painting. One should be large, usually numbered 12; one should be in the middle range, such as #7 or #8; and one should be a small detail brush, #2 or #3.

A few flat and pointed bristle brushes are good to achieve textures

This #8 red sable is capable of a great variety of shapes, lines, and textures.

Bristle brushes, normally used for oil or acrylics, are ideal for dry-brush textures. They can also be used to lift off areas of color.

and to lift off dried paint. Flat brushes from 1″ to 2″ are great for laying in large washes and executing a watercolor in broad terms. Try some of the house painters' small flat hair brushes, the kind used for varnish. Their cost is relatively low while their ability to handle big washes is excellent. Other brushes to consider are the inexpensive Japanese brushes used for calligraphy.

Brushes should be treated carefully. After use they should be rinsed thoroughly, pointed or shaped, and occasionally cleaned with mild soap and water. In storage moth balls keep off hungry winged creatures.

Boards and Easels
Boards support the stretched paper or loose sheets that are clipped or tacked on. To accommodate general paper sizes (22″ x 30″ or 15″ x 22″), boards with dimensions of 20″ x 26″ or 23″ x 31″ work well. For light weight and convenience of storage, 3/8″-thick basswood ply-

wood boards are ideal. Another good choice is a 3/4"- to 1"-thick drawing board. Some drawing boards use core construction, which keeps down the weight. Paper can also be stretched over stretcher bars (the kind used for oil-painting canvases) using thumbtacks or staples. Plastic boards that use wedges to hold the stretch are also available. They accommodate half-sheet sizes (15" x 22").

An easel may be formed simply from a cardboard box cut to a 15- to 20-degree angle where the board will rest. Boards can also be propped on stands formed from hinged pieces of wood. Camp stools or found objects like rocks or logs offer adequate off-the-ground support when painting outdoors. Home or studio painting areas can be established easily on tables or counters where boards can be propped up with any convenient item. Of course, more sophisticated manufactured easels can be used. Box easels are popular, as are the wood and the aluminum types.

Other Materials Watercolor work can be enhanced through the use of other materials and additives. A liquid mask called frisket is often applied to a working surface prior to painting to retain paper whites. This commercial latex fluid dries firm and is easily removed by rubbing or with a hard, rubbery frisket lift device. Drafting tape is also a useful masking device. It can be used for lineal effects or cut and torn to a desired shape. It is easily pulled off good paper after the painting dries to reveal sharp whites.

Wax crayons can be used either under or over watercolor to work as a resist medium or for enrichment. Pastels can be worked similarly. India ink is a natural additive for drawing and textural effects with pens, brushes, and fashioned implements (twigs, shaped wood, balsa sticks). A variety of media additives can also be used, including starch, glue, salt, alcohol, bleach, and turpentine. These additions affect paint in varying fashions by either attacking or separating pigments.

Knives and razor blades can be used to scrape, abrade, or cut paper surfaces either to lighten or reveal whites. Erasers lighten surfaces and sandpaper will appreciably change paint surfaces. Sponges, facial tissues, and paint rags are useful for lifting out color, creating patterns, or muting color areas. Toothbrushes and bristle brushes are marvelous for spattering textures either into wet areas for suffused effects, or over dry areas for additional surface interest.

Sketching Supplies Watercolor itself is a versatile sketching medium. Other sketching materials are also useful, including pencils, erasers, pen and ink, marker and felt pens, colored pencils, crayons, pastels, and charcoal. Sketchbooks are a must. Choose those with paintable paper. They are available in spiral and hardbound books in a variety of sizes. Small, prestretched watercolor blocks that encase 20 or 25 sheets can be useful in making quick studies and small, spontaneous watercolors.

Sketchbooks and drawing media, along with watercolors, are invaluable for working on ideas or tuning up sketching skills. Keep several for studies, improvisations, experiments, and informational material.

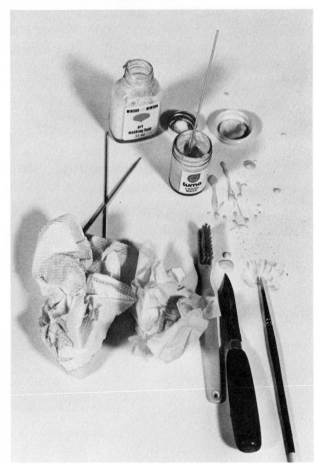

Liquid frisket or masking fluid is useful to block out whites. An old, inexpensive brush, shaped wood, and bamboo skewers are good applicators. A toothbrush and knife can spatter frisket for delicate light textural whites.

Basic Techniques and Approaches

Washes Watercolor painting requires the development of particular skills to assure competency. These skills involve wash proficiency, glazing knowledge and control, and the ability to manipulate brushes in a variety of ways. Once these skills have been mastered painting can be more confidently undertaken.

Washes give watercolor painting its substance, whether they form a gradated sky, flat buildings, diffused rock surfaces, or overlapping abstract shapes. Mastering the flat, gradated, and wet-into-wet wash techniques gives us remarkable control over the forms we produce.

Flat or plain washes, useful for portraying evenly lit surfaces and flat forms, are created by mixing a quantity of uniform color or value and applying it evenly to the paper's surface. To do this, slant the paper at approximately a 20-degree angle, load the brush with wash color, and start at the top of a prescribed shape. Pull the stroke across the shape horizontally. This fully loaded stroke will bead at the lower edge. The next stroke across will overlap and pick up this beaded line and form a new line at the bottom of the new stroke. Each beaded line of pigment provides a reservoir of pigment and water that feeds the next stroke and ensures a uniform paint surface. Carry this procedure throughout the shape adding more wash when needed until the bottom is reached. The last beaded area can be picked up with a squeezed-out brush tip. Leave the wash in the inclined position until it dries thoroughly. It is important not to go back into this wash to repair blemishes. With practice you'll achieve a uniform surface on the first application. This type of wash should be tried with all of your colors to see the different working qualities of each pigment.

Most shapes can be easily broken down into simple flat wash shapes. The roof, front and sides of a building structure can be treated as plain washes separated by value contrasts.

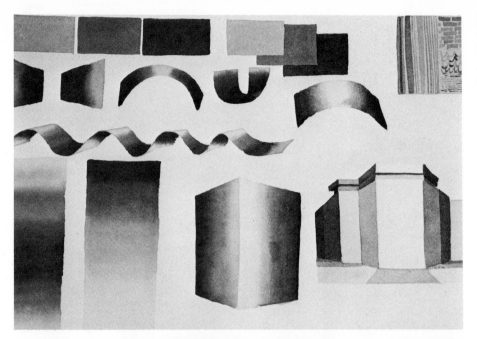

Filling several practice sheets with various washes builds confidence. Try light, medium and dark value washes. After flat washes, gradated washes are a logical follow-up.

Incorporating the beaded line that forms at the bottom of a wash stroke in each succeeding stroke assures an even wash surface. Upon completion excess wash is picked up with a squeezed-out brush.

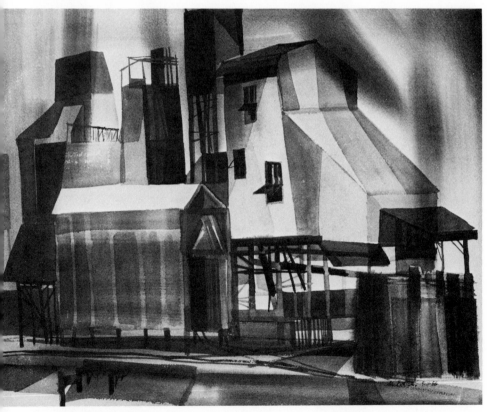

Flat washes formed these structures of an industrial site. After initial washes have dried, overlays of additional washes help to finalize forms.

Simplified figures can be easily formed with flat washes that describe the trunk, legs, arms, head, feet, and hands.

Sketchbook studies of silhouette figure shapes done with simple washes are useful in gaining control of figure scale and action.

Washes can produce shapes when painted around forms. These negative shapes may be composed of white paper or part of a previously painted wash (such as a background area). Later, further definition can be given to these silhouette shapes.

After practicing plain washes, try composing with flat shapes to produce a more complete statement, such as this invented buildingscape.

Creating a gradated wash is a variation of the flat wash procedure. Here the aim is to progressively lighten or darken the wash as it is pulled down. This gradual changing is caused by two distinct processes: (1) Start with a dark wash and add clear water to the wash mixture as you work downward to progressively lighten the wash until the final strokes become pure water; or (2) start with a light wash and add more color or value to it as you proceed downward. The last strokes will be almost pure color or the deepest values.

Gradated washes gives wonderful transitional tones to shapes and forms, and can be useful in portraying light changes and surface movement. The ultimate control of gradations is displayed in transitionally manipulating both color and value (the darkness or lightness of a color). For instance, a sky wash might move from a deep blue at the top through violets in the middle to a light orange at the horizon.

Transitional gradations are ideal for making curved forms. This roof structure is curved by using a light-to-dark wash.

Gradation in wash is controlled by the amount of dilution of the pigment as the wash is being painted. This wash is being modified by progressively adding more pigment to the wash as it is moved downward. Try gradation with shapes using the light-to-dark and dark-to-light techniques.

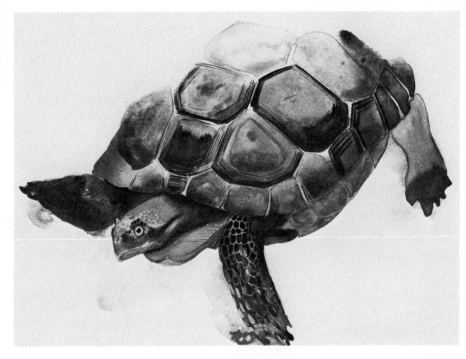

Alan Lugena's wash study of a turtle employs a variety of gradations to produce curved forms.

Wet-into-wet washes are ideal to depict the soft qualities of skies, flowers, and trees or the variations in rock forms. While washes are wet, tissues can be used to lift out cloud forms or to lighten foliage areas. A knife blade pushed across a wet wash will suggest tree trunks or branches.

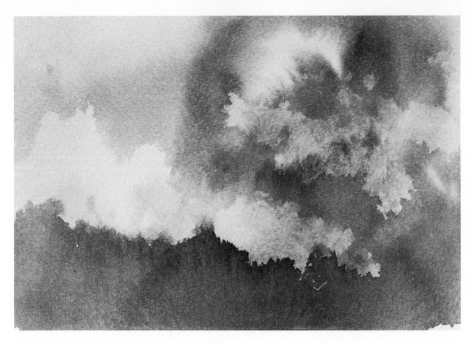

Wet-into-Wet Washes

For pure excitement, the wet-into-wet wash treatment is hard to beat with its fresh, rich colors and textural minglings. Watercolor is closely identified with this painting technique because of its suffused, fluid qualities. To create this wash, color is applied freely on a wet surface. Saturate the paper with clear water using a large brush or sponge and brush in, flip on, or spatter on the paint. Color can be applied at almost full strength and in varying hues and combinations. The colors will mingle, fuse, and create intriguing patterns. Since all watercolor dries lighter, it is wise to reinforce or charge colors with more pigment in areas where full strength is desired.

Wet-into-wet washes ideally portray soft textures and surfaces with mingled colors. Try a variety of color combinations and vigorous brush handling to acquire a feeling for wet-into-wet washes. Varying the angle and tilt of the board can increase the speed of color runs and their direction. Paintings can be worked on upside down or sideways if this expedites wash movement.

Explore dropping more color into wet-into-wet areas, or adding clean water droplets or sprinkles of salt when textured surfaces are desired. Bruising the paper with either a knife or the wooden end of the brush gives additional lineal effects. Light- and medium-weight paper can be crumpled in the wetting stage, painted with wet-into-wet techniques, and stretched to give a flat surface that will have a unique weblike lineal surface.

Be sure to let all wet-into-wet areas dry thoroughly before overpainting. The almost dry stage is the most dangerous for reentering the surface with a brush.

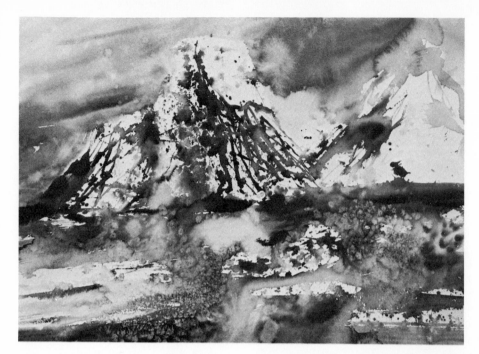

The wet-into-wet approach often accounts for most of a watercolor. In this seascape wet-into-wet washes establish the sky, rock forms and water area. Finalizing is done by clarifying areas with value and detail after the wet-into-wet areas are dry.

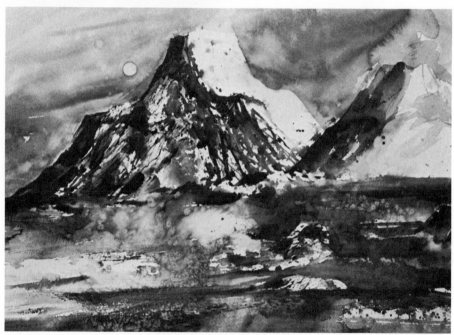

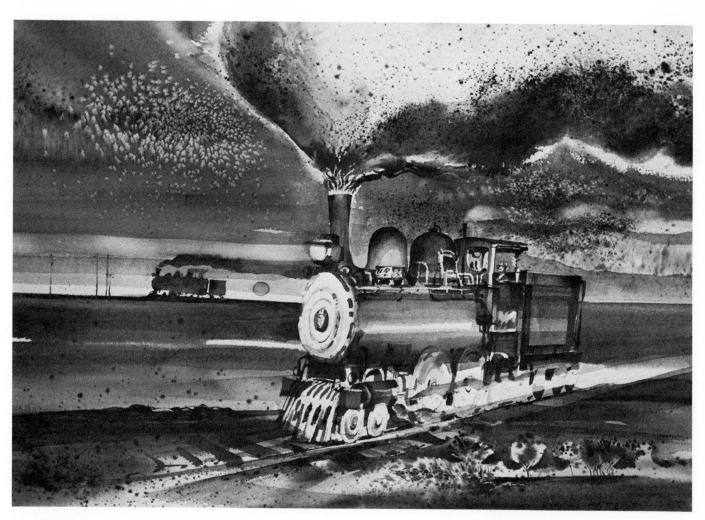

Wet-into-wet is used in this train
study by the author to capture smoke
shapes and textures as well as softer
foreground sections. Salt sprinkled
into wet washes produces the white
feathery texture. Similar texture is
achieved with toothbrush spatters into
wet-into-wet smoke shapes.

Glazing A glaze is a thin transparent wash used over dried washes to enhance or modify colors. The thinned color gives added depth to the color underneath. As glazes are layered, colors are mixed much as they would be in stacking pieces of transparent colored glass. All colors can be sufficiently thinned to achieve transparent qualities, but some colors are considerably better than others. Thalo blue and alizarin crimson, for instance, are powerful stainers and excellent glazers. Cadmium orange and cobalt blue are more opaque and cover surfaces more completely and so are poorer glazers. Some colors are grainier and these pigments lose some transparency. A good test is to make a grid of all of your colors by painting vertical stripes of fairly saturated color, letting them dry, and overpainting these stripes with horizontal stripes of the same colors. A look at this test sheet will not only show those colors that are effective glazers, but also the effects of one color over other colors. On another sheet overlay a variety of transparent glazes to see how color can be enhanced by glazing.

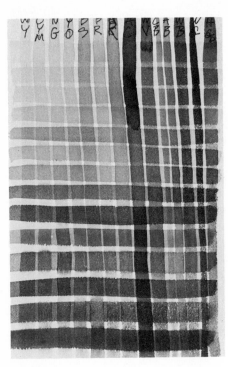

One of the best ways to ascertain the glazing capability of colors is to make a grid using all of the colors in the palette. Paint medium-strength color stripes of each color. After these dry overlay stripes of the same colors in the opposite direction. See color, page 88.

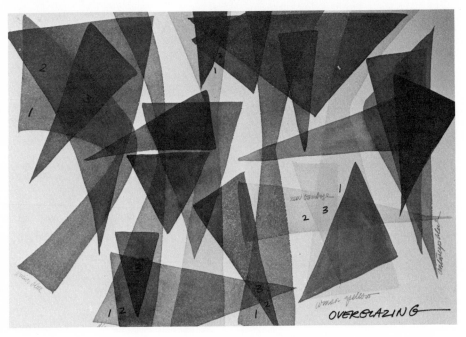

Try at least three overlays of thin glaze color to note transparent effects. Colors such as thalo blue and alizarin crimson are excellent for overlays.

Space Planes with Figures, Win Jones. Win Jones is a master of the glazing process. His handsome watercolor creates ethereal spatial qualities mainly through the judicious application of glazes.

The principal concern in glazing is to keep each color pure and relatively thin. Colors that have been intermixed as a result of brushing into several pigments will lose some of their clarity. Clean them off with a small sponge or a rinsed brush. A must for glazing is a thoroughly dry surface when each glaze is applied. Glazes are painted using the plain wash technique. In overpainting a light brush stroke is recommended since heavy brush action can disturb the underglaze and produce muddy effects. Generally, three or four overglazes are the limit; after this colors tend to build up a certain amount of opacity and thickness.

Paper surfaces also have an impact on glazing qualities. Linen rag papers are strongly preferred by most watercolorists and the cold-pressed surface is one of the most receptive to overglazing.

Brush Handling

How we hold and move a brush across a paper surface gives each stroke expression. We can be vigorous, bold or restrained. Our strokes can depict hard, powerful shapes or soft, diffused ones. The marvelous flexibility of our brushes gives us a wide latitude of form description. As we look at the inspirational brushwork of Oriental art and the watercolor masters, we can readily observe the eloquence of brush manipulation.

Skill in brush handling comes with practice. Taking each of our brushes and filling in practice sheets with single and complex strokes will give us a feel for brush potentials. How we grip the brush imparts visual qualities to the stroke. A firm grip imparts more vigor and energy while a looser hold imparts a freer, more flowing quality. Experiment with strokes of both types of grip. Also try holding the brush on different areas of the handle. Hold the brush at the end of the handle and try painting with a swinging action that employs arm action. Work your way down until you are finally gripping the brush on the metal ferrule and using slight wrist action. A brush can be pulled or pushed so that strokes move either toward or away from you. Speed of brush action is also important to stroke quality. Contrast quickly applied brush action with slow strokes.

A medium to large brush can hold a substantial quantity of wash and produce diverse strokes, such as thick-to-thin or thin lines to broad areas. The point of the brush can be used for lines and small shapes. The side of the brush can paint larger forms. The combination of point and side yields very complex strokes.

Dry-brush effects create appealing textures and surfaces. Brush hairs are separated, sparingly moistened with paint, and applied to paper so that each separate group of hairs leaves a mark. When painting such items as textured foliage or grassy areas, dry brush is ideal. Dry brush is also good for adding textures to wet surfaces.

Experiment with gripping the brush on different areas of the handle. The end-of-the-handle grip allows for wide arm movement; lower grips are useful for shorter strokes and tighter control.

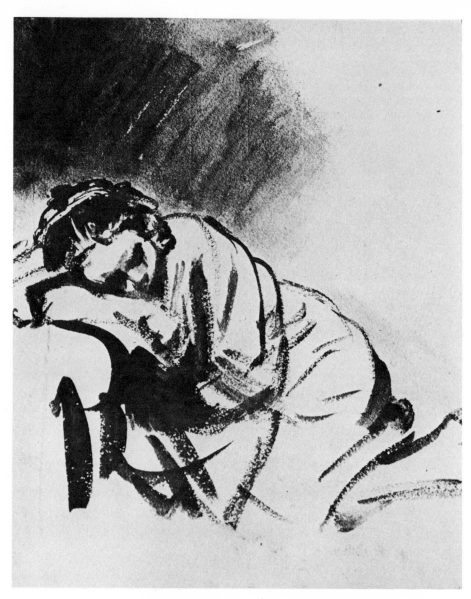

Girl Sleeping, Rembrandt van Ryn, British Museum, London. This eloquent brush drawing of a young girl points up the power of the brush to capture the essence of form.

Find out what each brush can do by experimenting with strokes in thick-to-thin and thin-to-thick areas.

Separate brush hairs and use spare amounts of paint and water for the dry-brush technique. Sweeping dry-brush strokes are excellent for describing grass forms.

Conch Fishermen, Bill Pajaud. This watercolor and both sketches display unique control over brush strokes to convey both information and aesthetic concerns.

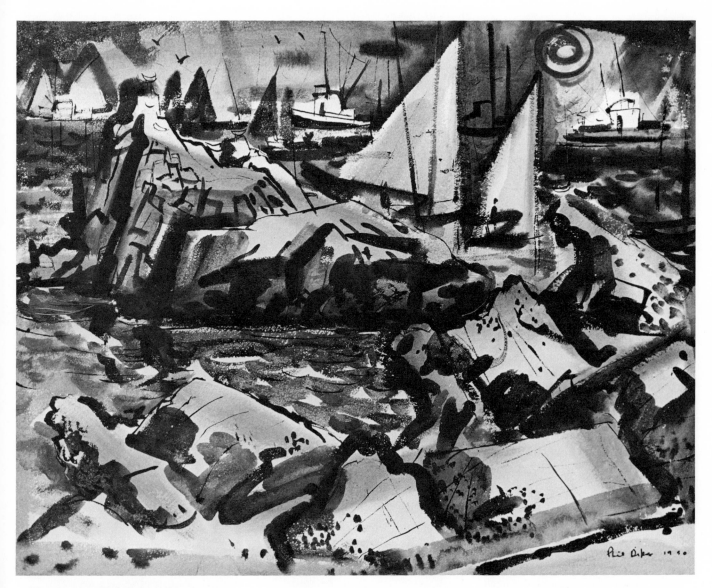

Golden Rocks, Phil Dike. The expressive use of brush strokes is the key-note in this rich and exciting watercolor of boats and rocks.

Brushes can be used in more unusual ways, such as in dropping paint, flipping it onto surfaces, scrubbing, rotating, and putting several colors on the same brush.

The brush is an excellent drawing tool to express line, shapes, and forms or to cover large areas. Many watercolorists use a limited number for most of their work. Certainly two or three usually suffice. Along with pointed brushes, flat hair brushes and some of the bristle types enhance our capabilities. Even the spatter from a toothbrush can add interest to surface effects that a more sophisticated brush can't duplicate.

Sketching Our impressions and feelings about the world around us, as well as our inner images, are resources for painting and should be recorded in sketchbooks. Sketching is also useful for surveying a painting site from many viewpoints and searching out the salient features. Sketching can warm us up and make us confident of competent results. A feeling about a subject's potential can be explored through quick sketches and small studies. Test out various arrangements of the subject matter; since the sketch can be quite small, executing a number of compositions is not overly time-consuming. Don't blunt the freshness of your approach by tedious drawing, however. Details are not important at this stage, so simply concern yourself with major shapes, value contrasts, dominant areas, and a sense of movement.

After executing a number of thumbnail sketches, select the one that seems to be the strongest as a starting guide. Quick color studies can also give valuable information on the mood of a subject, a general unifying scheme, contrast areas, and overall impact.

At times painting without prior sketching affords a more creative result. Even pencil guidelines can be eliminated or used sparingly.

Sketching for its own sake is highly rewarding. It builds skills, confidence, and gives us a rich repository of ideas and information. Explore a variety of media and approaches: pencil, pen, markers, brush studies, and color explorations. A sketch kit is a fine supplement to regular watercolor equipment. Many paintings can develop from the sketchbook pages, so having several filled sketchbooks can keep your paintings flowing when on-site activity is not possible.

Sketchbook studies, such as these quick descriptions of sailboats, are good warm-ups for painting. Marker pens are excellent for describing line and general values.

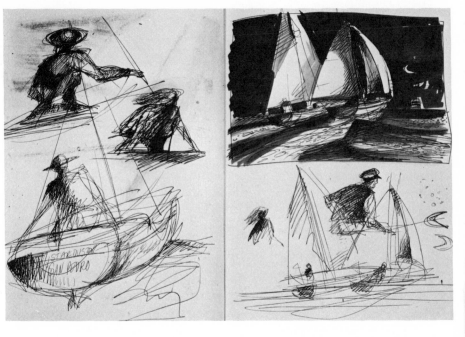

Robert E. Wood's sketchbooks investigate many parts of the world with consummate skill. He uses a variety of media to register his impressions.

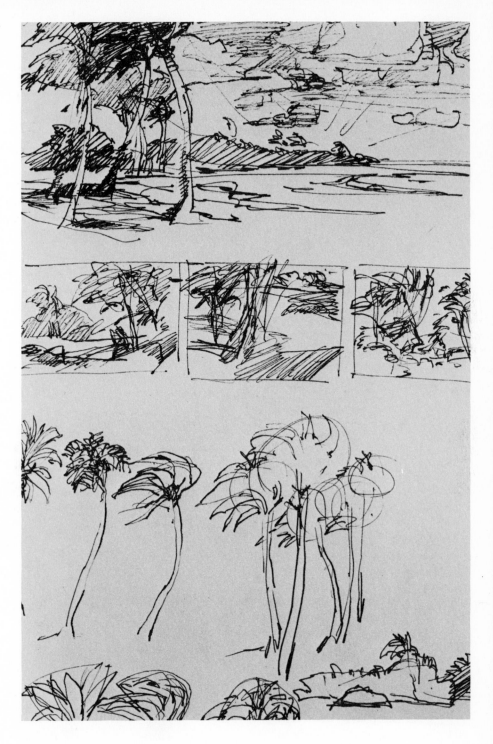

Additional Techniques

Watercolor readily adapts itself to mixture with other media, and experimentation with a variety of paints, drawing tools, and additives can often stimulate creativity. Watercolor can play either a passive or a dominant role in mixed media applications. It may simply provide a wash background for superimposed media, or other media may be applied to affect the watercolor paint.

Watercolor and drawing media seem naturally allied. Pen and ink, black and colored pencils, wax and oil pastel crayons, and marking or felt-tip pens work effectively either over or under washes of watercolor paint.

Pen and Ink

A great variety of bottled inks and dyes are available for use with pens and brushes. Many inks are waterproof thus providing nonbleeding effects when dry. Fountain pen drawing inks are nonclogging and work well in fountain pens or with regular pen points.

India ink spreads rapidly in wet watercolor washes. The resultant feathery line adds textural interest. Try regular pen points, wood sticks, and twigs to explore line qualities.

Stick drawings with balsa wood or chopsticks give a lively line. Pulling and pushing the implement yields such varying effects as dotted lines and thick-and-thin lines. Still life objects are excellent for such ink and wash studies. Employ wash both under and over line to suggest general masses.

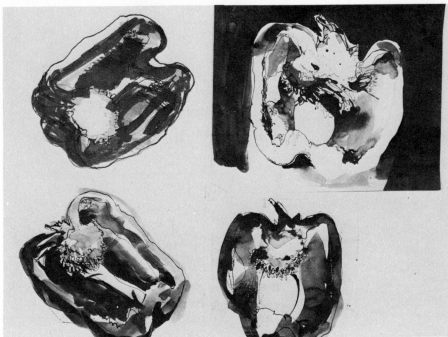

A bell pepper sliced in half offers an intriguing subject for a variety of ink-and-wash studies. Combining pen-and-ink and stick line increases line sensitivity.

Quick, gestural figure drawings are
easily amplified with watercolor wash.
India ink and ballpoint pen were used
here.

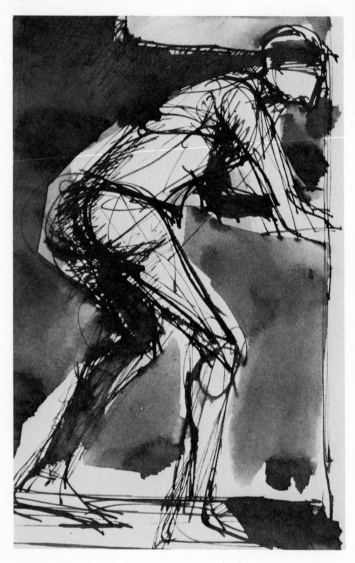

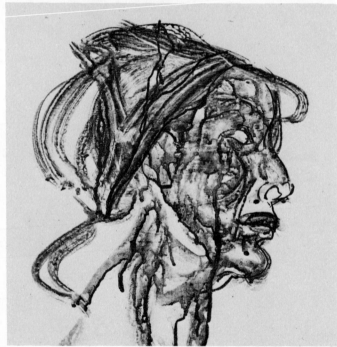

Thinned ink wash brushed onto a
slick surface will create more obvious
brush strokes and runs. The head
study is done on paper treated with
gesso.

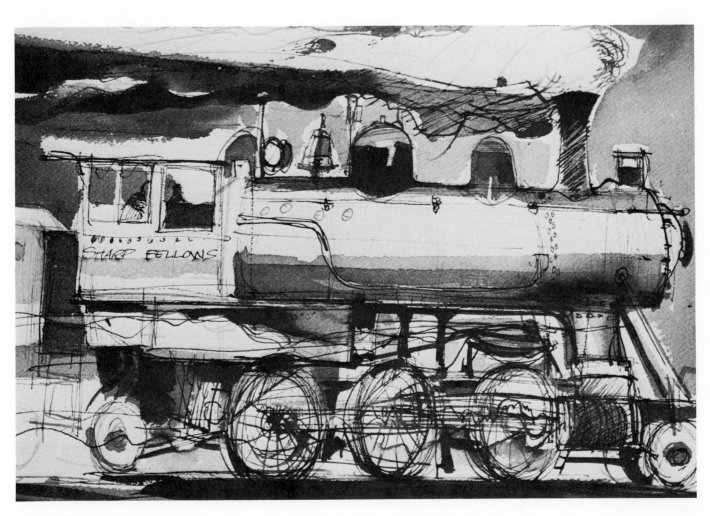

Wash and ink give substance to
sketches.

Sponging

Sponges are ideal for modifying water-color washes. Parts of this sky wash have been lifted off with a rinsed sponge to achieve white cloud forms.

Paint applied to a sponge can be used in lieu of a brush for covering an area using a brushing action, or stamped over a dried wash area when texture is desired.

This tree's foliage was created with a paint-covered sponge. When dry, trunk and branches can be added with a brush.

Spatter

Flung paint or ink has a dynamic quality that can enliven wash areas. The speed of the flipped action, along with brush size and amount of paint used, determines the size and value of resulting spatters.

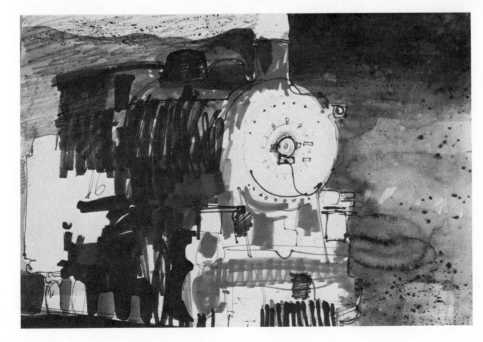

This train study was drawn with colored felt marker pens. Watercolor wash was used for the background and foreground areas. Flipped paint adds some atmospheric texture.

Printing

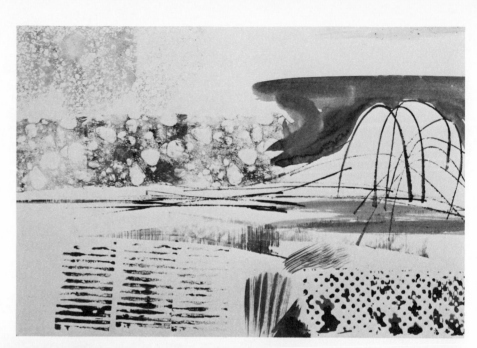

Various cellulose and natural sponges are useful for patterning textured walls or rock surfaces. Stripped corrugated cardboard gives uniform lineal patterns.

Most of this watercolor has been printed with sections of mat board cut to form sail shapes and rock forms. A section of a cellulose sponge printed the smaller rock textures.

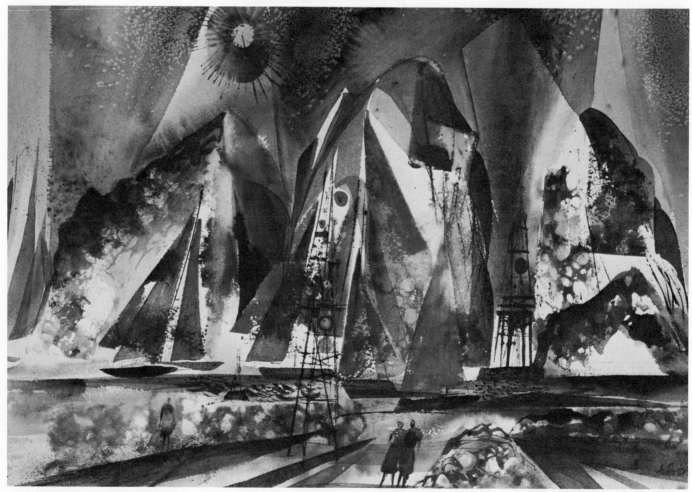

Additives

Denatured alcohol applied to a wet wash with a cotton swab formed these light shapes. A variety of sizes can be achieved by varying the amount of alcohol and the degree of wetness of the wash.

Salt sprinkled into a wet wash can produce unusual textural effects. How much salt is used and how much wetness exists are important criteria for successful results. Experimenting with various colors and salt amounts will help to assure the right effect for serious work.

Crayon Resist

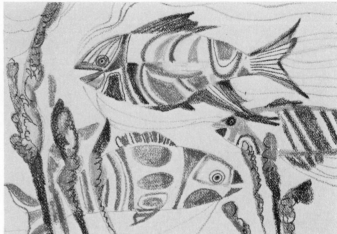

Crayon and watercolor is a popular mixed media approach that produces rich, colorful effects. The process involves blocking in the design with pencil, laying on layers of crayon color, and finalizing with overlaid washes of watercolor, which the crayon resists. Additional enrichment can be achieved by more crayon or pen-and-ink line.

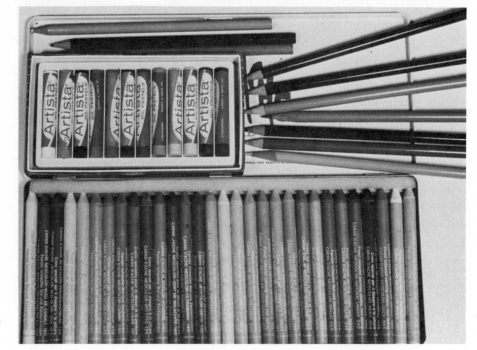

Oil pastels also resist watercolor washes. Colored pencils are useful for enriching dried watercolor washes.

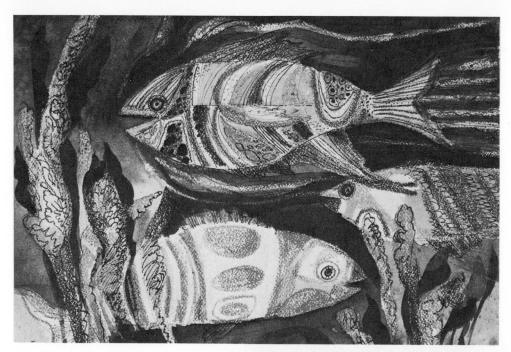

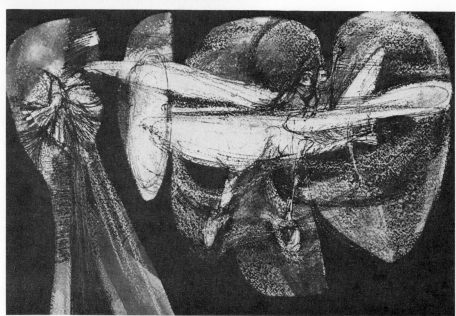

Crayon resist can be easily treated
with pen-and-ink line, and an acrylic
wash can be utilized for painting
background areas.

Inventive Approaches

Three painting approaches provide excellent learning and creative possibilities: collage, the use of tapes, and the use of resist media. Collage makes use of a variety of techniques to achieve rich colors, captivating patterns, and expressive textures. Tapes can be employed as devices for designing and overglazing, while intriguing white paper patterns can be achieved with resists. The subject matter for these inventive approaches can be anything that lends itself to expressive abstract treatment.

Collage Collage, the process of adhering pieces of materials to a surface, provides an ideal way for the watercolorist to overcome artistic inhibitions. Experimentation and organization are easy with collage, and since only the best pieces will be used in the finished work, there is no pressure to produce totally finished or completely successful trial sheets. Another plus is the wide variety of techniques that can be utilized to develop materials. Practically all of the basic and innovative approaches can be employed: flat washes, gradated areas, wet-into-wet treatments, flips and drips, salt and water blooms (soft feathered edges), resists, and versatile brush strokes. As many techniques as possible should be explored to produce a rich collection of colors, patterns, and textures to capture the qualities of the selected subject matter.

To provide a unifying theme, the subject matter used in the following instructions is exotic plant forms. Another subject could easily be used, such as a landscape, figure, still life, or pure abstraction.

Soft textural qualities are easily achieved with wet-into-wet color insertions. Salt sprinkled into wet paint produces small, fused white spots when dry.

The Process Start with a full palette, an ample supply of papers (inexpensive watercolor papers can be effective), several brushes of different sizes, liquid frisket and applicators, salt, a spray bottle, a small natural sponge, and a supply of water.

Use several small sheets or one large sheet to paint a number of strong, rich color areas. Some of these can be flat, even washes; for others, explore gradations of either one color or of several transitional colors (e.g., yellow to orange to red). These latter washes should be blended carefully to achieve a gradual fusion of colors.

Follow these first wash trials with a series of wet-into-wet color insertions by brushing several areas of undiluted paint into wet surfaces. These colors blend freely but will dry less intense, so some sections will need to be charged with additional paint before they dry.

Some of the wet-into-wet applications can be manipulated by placing the paper or supporting board in a steeply inclined position. This will create intriguing runs of color. Paint runs can also be created by blowing wet paint in desired directions. Attacking the edges of freshly painted swatches of color with a spray bottle of water produces soft diffused runs with patterns of fine tracery.

Both table and kosher salt sprinkled into damp color yields starlike blooms when dry caused by the salt's soaking up color and leaving small, diffused white spots. The salt should be brushed off after the surface dries. Less pronounced blooms can be achieved by flicking water from a brush onto a damp, painted area.

Brush Strokes and Patterns The brush is a marvelous pattern and texture producer. Strokes can suggest a wide variety of textural qualities: thin, delicate groupings; heavy, bold arrangements; thin-to-thick variations using pressure changes; dry-brush effects caused by dragging the brush across the paper, dabs of color; even bruises and abrasions of the paper using the wooden end of the brush.

Frisket applied with brushes and sticks preserves white paper areas during painting and can be removed after color washes are dry.

Resists, Whites, and Scratched Textures Resist mediums, which will be treated separately in the last exploration, can produce striking areas of textural whites. Liquid frisket is a versatile masking solution that is easily applied to paper with wooden sticks (such as the bamboo skewers used for kabobs) or inexpensive brushes. Dip into the solution and explore the possibilities of brushing, flipping onto the paper with sticks, or making small, intricate patterns with short strokes or dots.

After filling a sheet or two with applicatons of frisket, let it dry (you can hasten the drying by directing the air from a hair dryer above the applied frisket). Then overwash the dried frisket with watercolor. Try a variety of washes and color combinations. After these washes dry, frisket can be either fully or partially removed by finger rubbing or with a rubber lift device to reveal white areas. More frisket can be added and painted over if more depth of texture is needed.

Other whites for your collage can be made by painting around desired shapes (try this with leaves, petals, and stems), or by lifting paint from either wet-into-wet areas or dried areas with a clean, damp sponge. By manipulating the sponging process, interesting edges and diffused shapes can be created. Finally, some areas of scratched whites can be made for finer lines and textures. A sharp razor knife works effectively to reveal whites in dried, deep-toned areas.

Creating the Collage Pieces With a collection of trial sheets and swatches of improvised patterns, textures, and color areas at hand, you can now give thought to subject matter treatment. In floral designs the possibilities seem endless. Take some of the areas that suggest flower forms and cut these out of the trial sheet with a razor on a wooden or cardboard surface. Work for a collection of varied sizes of flower shapes, leaf shapes, and stems. Think also of smaller parts and units that can be assembled as a composite for plant parts.

After cutting out a variety of possible parts for the collage, start streamlining shapes by tearing or cutting them further. Tearing is recommended as a way to achieve rich, flowing forms that have a less contrived look than do mechanically cut shapes. By pulling the excess surface up in the tearing process, a white deckled edge is created on the form; by tearing the excess material away from you, no white paper is exposed. Practice tearing sample sheets to achieve control of white and irregular edges. Vary the speed of pulling the paper for irregularities. Some units can be made of composites of pieces rather than of single forms; others can be opened up inside shapes by cutting or tearing out the centers so that smaller pieces can be inserted. Try to vary shapes enough for interest, and repeat shapes and textures to achieve unity. It's a good idea to have one or two dominant parts as eye-catching focal points. These may be the units that are visually arresting in size, color, pattern, or texture.

Select shapes that suggest forms. Through cutting and tearing, these shapes have been transformed into floral units.

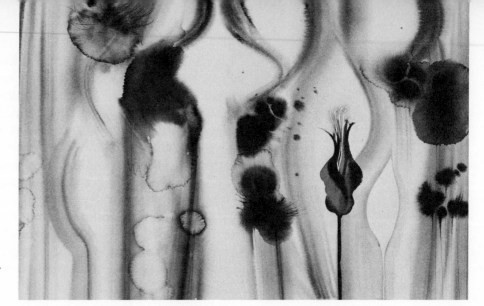

A freely applied background sets the stage for the collage. Think of movement and pattern with only generalized shapes and a minimum of detail. Blooms can become distant background forms.

The Background A wet-into-wet background is a natural complement to the collage pieces. A full- or half-size stretched sheet of good quality watercolor paper is advisable for background work. Thoroughly wet the stretched surface so that the colors will diffuse and provide an atmospheric quality. Pick a color scheme that fits most of the pieces that will be used in your collage. Some pretesting can assist the decision on suitable color contrasts.

For the plant forms illustrated, think primarily of patterns that suggest growth, energy, and tropical lushness. Some fused shapes painted into a wet surface can echo the cut and torn shapes. Add some background textures with flipped paint, water spots, and possibly salt. Work just enough to achieve a visually intriguing backdrop.

Once the surface starts to dry, leave it alone. Some small painted shapes can be applied over the dried background if desired. Keep these close to the general tonal and color qualities of the background itself.

Completing the Collage Putting the pieces together in an exciting fashion is now the challenge. First select the best pieces and discard or set aside all others. Place the chosen ones on the background paper to obtain the desired effect. Manipulate the composition before determining the final placement.

Once the decision has been made, glue the pieces in place. White vinyl plastic glue is a strong, workable medium well suited to collage, and glue dispensers make the process simple. Pick up one piece at a time and carefully apply glue to the back surface, spreading it thinly so that no excess is squeezed out when the shape is pressed down. Press each glued piece into place until all parts are affixed. This includes supporting stems and smaller details. Not all floral forms need cut or torn stems; some can be painted in later.

To finalize the composition, add painted details and background forms. Simple silhouettes, produced either by painting around a background area or by direct application of wash shapes, are excellent to suggest depth and to enrich uninteresting background areas. More stems, foliage, and textural details can be added with the brush. Details and reinforcement of the shapes themselves can be considered. Painting additional patterns onto collage parts can heighten the effect you desire. Thin rice paper may be glued on areas that seem too dominant, and subtly tinted to give a slightly translucent quality. The last touches are often an intuitive response to the composition.

The collage is now complete and ready for matting or framing. Since an excess of collage parts is produced, more than one collage may be undertaken at a time. This provides the opportunity to vary approaches and reach for new effects.

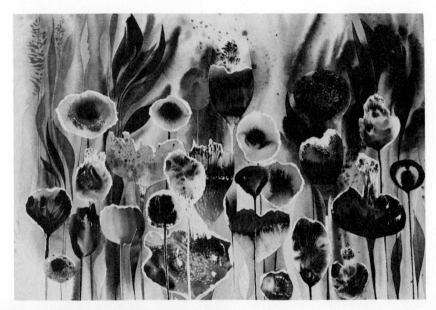

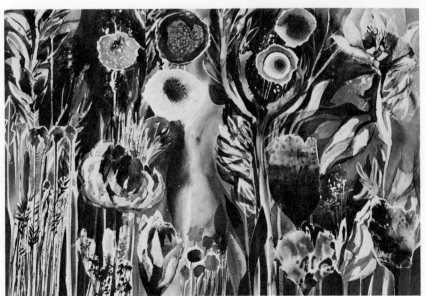

These imaginative floral collages exemplify the use of torn and cut shapes on wet-into-wet backgrounds. The backgrounds and some of the shapes can be painted in order to heighten the effects after the pieces have been glued.

Tapes One of the attractive aspects of watercolor is the transparent glaze. The thin enhancing overlays provide unique color qualities. As transparent glazes are superimposed over other glazes, a luminosity is achieved that can rarely be duplicated by other media. Taking some time to deal exclusively with glazes is important in watercolor experience. Using tapes in this exploration allows us to produce crisp, hard-edge paintings.

The Materials Drafting tape used on good-quality, stretched watercolor paper (preferably the smooth, cold-pressed surface) assures the best results. Standard widths are 1/4", 1/2", and 1". The 1/4" width is a good standard size suited to watercolor sheet dimensions. With a straight edge, a razor knife, and a wood surface, various shapes and widths can be cut from drafting tape.

Masking tape is a good second choice, although it has a tendency to tear lesser quality papers during tape removal and leaves a slight gummy residue. Commercial graphic designer tapes are ideal supplements to drafting tapes. They come in smaller widths such as 1/8"and 1/32". Along with tapes, various press-on devices found in stationery stores are useful. These come in many shapes, such as circles, rectangles, and dots.

The Process It is imperative to start with a firmly secured watercolor stretch since any buckling of the surface is a considerable handicap. If the stretch is weak, remove the paper and resoak and restretch it. Adding staples to the butcher tape will ensure a perfectly tightened paper.

Designing the composition requires placing the tapes on the paper at intervals that create a variety of shape sizes and repeated patterns and provide directional interest. Starting with the wider tapes

Step one is to develop an intriguing interplay of shapes and movements using tapes to divide the format's space.

First washes are usually of light value, but some darks may be inserted for contrast. Dark areas are not meant to be overglazed.

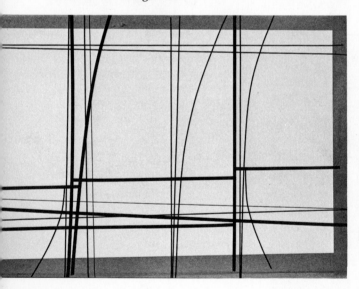

Small press-ons and dots of frisket are useful for pattern and textural interest.

provides a framework for the composition. Breaking into this framework with narrower tapes will modify the initial arrangement. Curves can easily be formed by adhering one end of the tape to the edge of the board and holding the tape taut with one hand while pulling and pressing down the tape with the other hand. The narrower the tape, the easier it is to curve. After the tapes have been arranged, make sure they are firmly pressed into place. Even after securing the tapes, press them yet again before individual areas are painted. Heat and atmospheric changes may lift the tapes slightly and allow seepage of the washes.

Painting from light to dark is recommended. Be sure the paint is thinned to transparency. Thick pigment is difficult to overglaze and so should be avoided. A natural buildup of pigment density occurs as overlays are made. Three overlays of color may be desirable for some areas; stretching this to four or five overlays would be courting undesirable results unless carefully and judiciously applied with very thin glazes.

Mix adequate amounts of wash to cover each area; matching a glaze color is almost impossible. Distribute the initial washes over the whole composition and work for a general organization of light and medium values. A few darks may be placed into areas that will not be overglazed later. These darks provide contrast and visual movement.

Make sure all of the first washes are completely dry before subsequent glazes are applied. A light brushing action is required when painting overglazes so as not to disturb the underpainting. Try building up several areas with a succession of glazes to achieve a

This four-piece design has had the tapes removed and is ready to be cut into four small watercolors. Tape design and painted movement link all four units.

more complex configuration. Along with following the design produced by the tapes themselves, explore glazing across areas freehand. Some of this type of overglazing can be done to echo shapes and also create paths of movement throughout the composition. Varying color intensity, as well as value range, will give the painting a luxuriant, stained-glass appearance. Glazes can also be used to suppress color areas that may be too intense.

After the last washes are completely dry, the tapes can be carefully removed. If desired, further glazes may be applied over some of the exposed white lineal areas, or sections of white may be tinted to suppress the gridlike appearance. Any additional painting must be carefully considered so that areas are not overworked. The hard-edged result can now be matted to give the final contrast of white mat against the glazed surface.

An interesting variation of the hard-edge painting process is breaking a full sheet into units of three or more shapes that will be cut off eventually and matted separately. Thus, a series of small, related hard-edge watercolors is produced.

Torn-Tape After trying the hard-edge glaze technique, it is stimulating to employ torn tapes for subject matter interpretations. Torn tapes furnish appealing shapes that easily suggest such subjects as rock forms, tree shapes, or cloud patterns.

The small, imaginative landscape demonstrated on these pages shows the process and development from tape placement to final details.

Torn drafting tape is pressed onto stretched paper to create a succession of land forms. A press-on device represents the sun. Small graphic designer tapes break up the foreground and middleground areas.

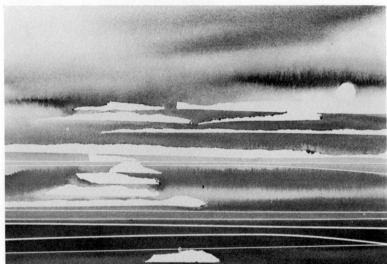

Washes of color are brushed over the secured tapes to capture qualities of land and sky.

Tapes are carefully removed after washes are dry to reveal white paper areas.

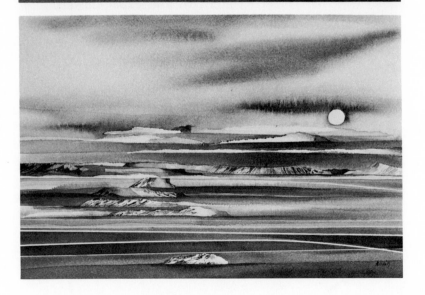

White areas are painted in sufficient detail to suggest mountain and cloud forms. Foreground and middleground areas are heightened with additional glaze washes.

By painting over a series of frisket overlays, rich textural qualities are achieved. These can be reinforced with painted details.

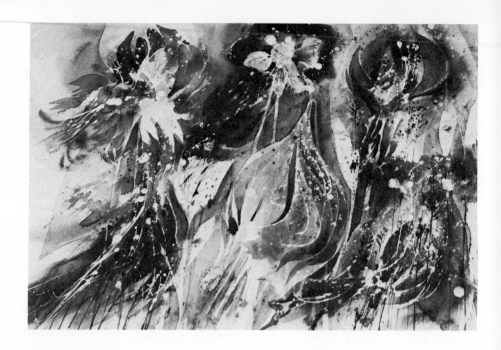

Liquid Frisket Commercial liquid masking solution, known as frisket, is highly effective in creating textural patterns. As explained in the collage section, frisket can be applied with various tools such as sticks, brushes, or toothbrushes. Bamboo skewers and wooden chopsticks work well. Inexpensive brushes offer control and flexibility. Since this latex material dries to a waterproof firmness, brushes have to be rinsed in water immediately after use. Although rubber cement thinner can be used for removing frisket from coated brushes, it is difficult to return brushes to their original flexibility. You may want to use bristle brushes with frisket because they are easier to revive.

Compositions with frisket can be controlled by careful brushing, stencils, and paper masking. However, freely applied frisket has a more spirited look.

Flipping, dripping, and pushing and pulling sticks are some of the methods that create textural patterns. Arc-like arrangements of lines, dots, and attenuated shapes are created by whipping frisket from sticks or brushes. The amount of frisket loaded onto the implement determines the size of the shapes created. Lines and patterns can also be painted on with brushes. Finer textures are readily achieved with spatters from a loaded toothbrush scraped with an inflexible tool such as a knife. To control areas of fine spatter, cut paper stencils into desired shapes and lay these on any surfaces you wish to protect.

The objective is to freely improvise patterns that create a sense of movement and energy. Repeating directions and textural qualities imparts a feeling of unity. Focal points or centers of interest can be acquired by the quantity of texture applied and the vigor of lineal action.

The steps are relatively simple. First apply the frisket, then let it dry (aided by a hair dryer if desired). Next apply washes of color, allow them to dry, and remove the frisket. Final details can be added with a brush.

Added textural richness is built by partially removing frisket after the first washes are dry and applying frisket in new areas. This process can be repeated several times so that frisket overlays achieve a web of patterns.

An easy-to-handle resist medium, liquid frisket can be given a minor role in a more literal painting or fully engaged to dominate a composition.

Liquid frisket can be removed by rubbing off the latex material after it has dried. A rubber cement and frisket remover can also be used to clean surfaces.

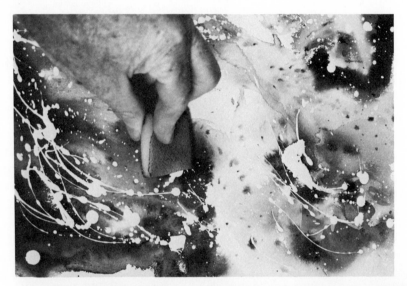

Exploring abstract compositions with frisket underlays develops an understanding of resist potentials.

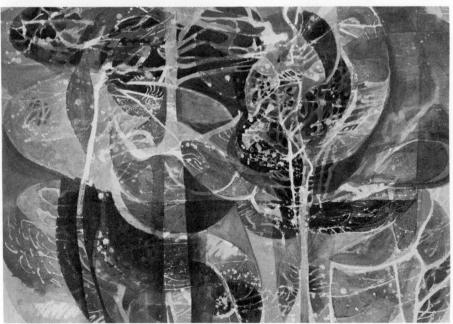

Improvisation

Many works of art are created without previous preparation (other than the artist's experiences and skills) and seem to happen spontaneously. The excitement of painting is increased when the unpredictable is allowed to take place. By its very nature, watercolor lends itself to improvisation. Subject matter and compositions can be discovered in freely applied paint and creative manipulation of pigment, water and paper. Heightened awareness of improvisation, when combined with the needed restraints of compositional description, affords the best opportunity to work on an artistically expressive level.

Idea Development

Ideas come from many sources: our visual surroundings, our feelings and emotions, our intellectual pursuits, and our imaginations. One can develop ideas through research, sketching, and manipulation of elements until the idea comes into proper focus.

Equally important is allowing for spontaneity in response to outside visual information or to inner reactions and imagining. Sketchbooks are useful for experimentation and idea development. Some of this activity can be the playful exploration of lines, shapes, colors, textures, and space. A page of intermingling forms might easily trigger a new idea that would not have been deliberately formed. A series of improvised lines could suggest the feeling of a landscape or a group of figures. Freely applied watercolor washes offer a similar opportunity for images to form. These can be further clarified with more careful applications of paint or drawn line.

Paintings are based on ideas, so the development of ideas is an important skill to develop and nurture. Constant exploration of outer and inner resources is a prerequisite for those who wish to produce a stream of significant work.

Wet-into-Wet Imagery

The luscious richness of wet watercolor is an ideal image-maker. The freedom of working with the wet-into-wet technique prevents the more static piece-by-piece painting approach that restricts the flow of inventive ideas. This approach stresses a loose, overall involvement with pigment mingling on a saturated surface.

Try a series of wet-into-wet studies and follow-up paintings in which the main thrust is to suggest, to improvise, and to allow images to form and present themselves.

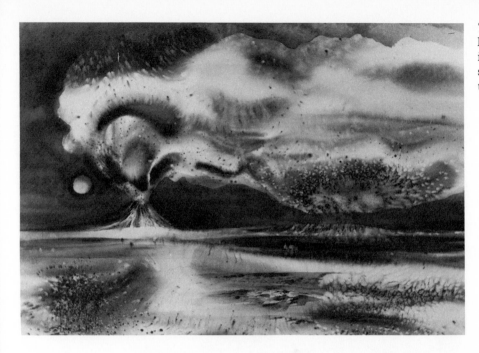

The Big Show, collection of Sid and Esther Rosenfeld. The volcanic activity of Mount St. Helens sparked a series of watercolors on the theme of the earth's eruptive forces.

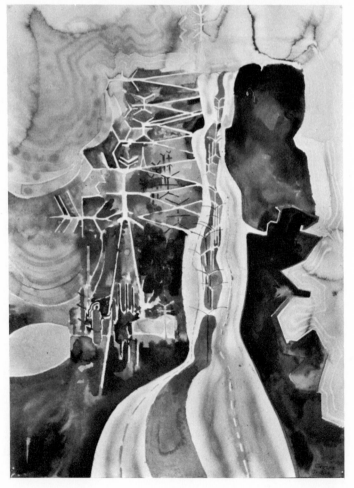

Rosencrans Blvd., Keith Crown. This painting reflects Keith Crown's consummate control of wet-into-wet usage. The images flow powerfully from suffused areas to contrasting crisper shapes.

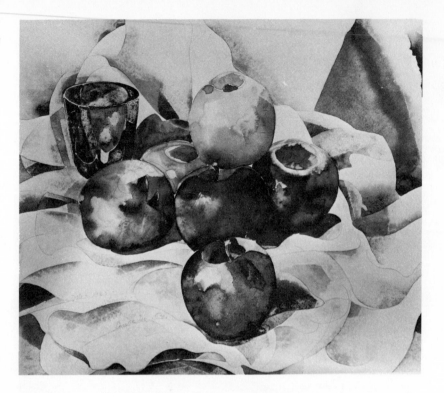

Apples, Charles Demuth, courtesy of the Art Institute of Chicago. Skillfully employed wet-into-wet techniques capture the surface variation of the fruit and drapery material in this painting. The soft textural areas effectively contrast with the hard, crisp edges.

Wet-into-wet painting requires a thoroughly saturated paper surface. Clear water can be brushed or sponged on until the surface produces a wet sheet (300-lb. paper is ideal for this). With unstretched paper both sides can be thoroughly wetted, which will keep the painting surface wet for a longer period. During the painting process, rewetting can be done with a sprayer. Hence, the wet-into-wet technique can be kept in action for an extended period (two or three times normal drying period, approximately one hour or more). Wet-into-wet painting, however, is often consummated in relatively short painting sessions.

Since the paper carries the water, pigment can be used nearer to full strength than usual. Values can also be used in stronger contrasts. The wet surface will mute and effectively soften even the strongest colors, although the staining colors will retain considerable potency. Usually, watercolor paint dries several shades lighter than it looks at first insertion. If you wish to keep color and value strong, recharging will sustain the first impression.

Unevenness in the wetness of the paper surface will create irregularities that can benefit wet-into-wet minglings. Wet areas will flow into drying areas to form blooms or feathered shapes. Blooms can be also induced by dropping small quantities of clear water or color onto a drying wash. Such textures are exciting in skies and rocks. Similar effects are produced by sprinkling salt into a wet color area. Table salt makes small white bursts while larger salt crystals (kosher salt) produce larger versions.

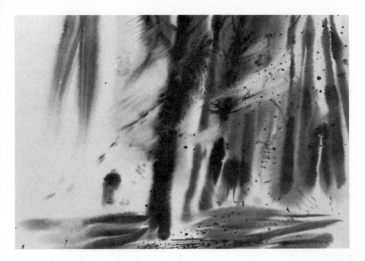

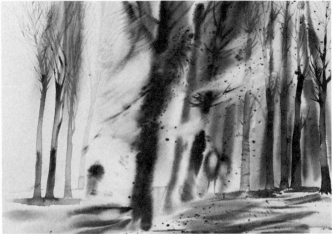

Wind whipping through tree forms is the subject of this watercolor study. Work began with a wet surface into which directional thrusts of tree forms were stroked. The ground plane was suggested, as were the figure forms. In stage two silhouetted background trees were added to the dried surface. Stage three was the completion process in which clarifying darks, details, and textures were added.

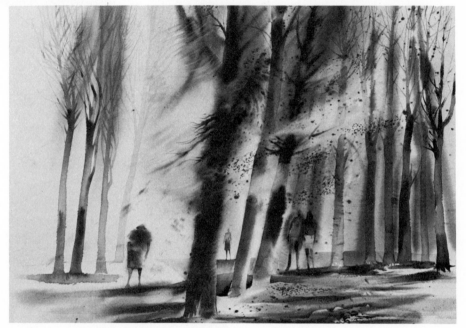

Other modifications to wet washes can be executed by sponging, scraping, bruising the paper, and adding color with toothbrushes and brush techniques. Once a wash starts to set, the sponge (small rock sponges work well) can be employed to lift color or move it across the surface in soft directional strokes. A slightly damp sponge can also create patterns when pressed into wet washes.

As the wet-into-wet work dries, more deliberate actions can be employed with brushes and other tools. Try flipping in paint from several sizes of brushes. Adding color to a wet surface with the dry-brush technique gives soft fused lines and textures. Scraping into wet paint with knives and the edges of cardboard creates forceful edges and lines.

After experimenting with various wet-into-wet approaches, try painting vigorously to capture the qualities of your subject: a stormy, threatening sky; the vertical elegance of trees; mysterious figures in a half-lit environment. The brush should move freely to establish directional movement of forms and to trap the energies of our subject matter. Insert some strong darks and several areas of strong color accents.

Decide where you want your focal points and give those areas stronger applications of color, value, and textural interest. Establish a pattern of movement early in your painting; an overall pattern should unify the composition while more specific patterns move the eye of the observer to the focal points. Many of these staged movements become suffused backdrops for clearer images to be played against.

When the wet-into-wet painting explorations have been completed and general impressions achieved, allow the surface to dry completely. Then finalize your statement with overwashes and detail.

Inventing from Backgrounds

Pulling ideas from a painted background sharpens imaginative powers. Forms or subject matter can emerge from suggestions of shapes, colors, and textures in a background by coaxing these images into form. You can paint around a suggested form, thereby clarifying its shape, or you can add value and detail to the existing suggestion to make it read.

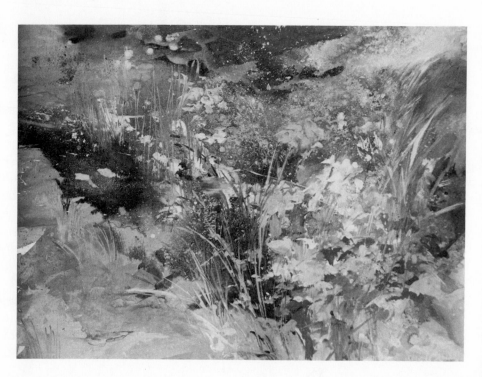

A Secret Place, Mary Jane Kieffer, collection of the National Watercolor Society. This handsome watercolor capably uses the background as a perfect foil for inserted plant forms.

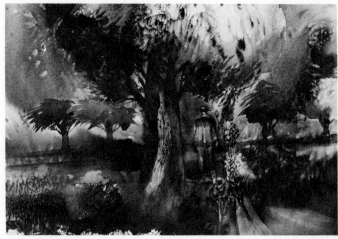

In this two-step demonstration of pulling ideas from the background, the initial wet-into-wet surface of cascading movement becomes a series of tree forms, foreground plants, and a figure.

If the imagery in the background is especially vague, arbitrary shapes can be painted in. Simply paint either positive or negative shapes to state the subject matter. Areas and forms can also be produced by lifting out color with a wet sponge or a wet brush. This will bring that area back to almost a pure white; it can then be left as a white shape or painted in a new form. Most of the time backgrounds give us enough clues for images so heightening shapes is all that is needed. Wet-into-wet backgrounds give us the most possibilities, but even more conventional or literal treatments can be modified by inventive additions.

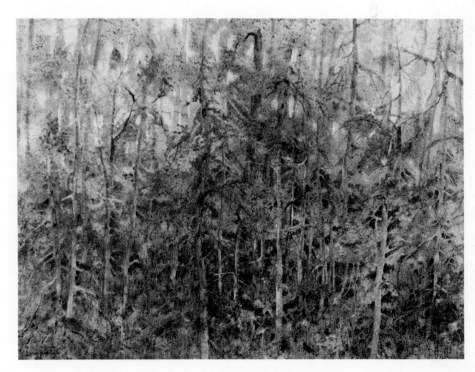

Forest Light, Lee Weiss, collection of Mr. and Mrs. James J. Lyons. Weiss is an expert at improvisation. By monoprinting a rich textural background surface, she explores an effective slice of imaginative nature.

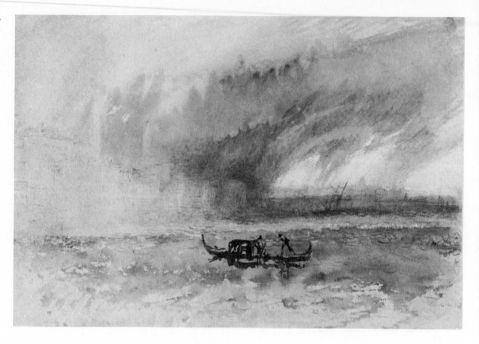

Venice: A Storm, William Turner, collection of the British Museum, London. William Turner dramatizes a scene of Venice with a large spatial background onto which a few significant details are superimposed.

Stylizing Forms Invention implies changing the ordinary into more stimulating solutions. Exaggeration, simplification, and alteration are means of improving shapes and forms. Just as fashion illustrators elongate figures to produce more elegant shapes for displaying the latest fashions, so can the artist take whatever liberties necessary to increase the visual impact. The shape of subject matter, the choice of color and value, and the treatment of texture can all be changed. The arrangement of these elements can also be altered. Stylizing is a term used to describe this alteration process. It means to change the form and give it a new appearance.

Exaggerating or stretching a shape provides visual excitement. The idea here is to heighten the character of the form: If it is tall, make it taller; if it is wide, wider; if it is thin, even thinner. Also try to simplify color and value patterns. Some shapes can be suggested just by silhouettes. A slightly modified color may work better than several colors. Textures can be corralled into areas rather than sprinkled all over.

What is important is to stress and emphasize the salient features and to eliminate the extraneous. Sketchbooks are ideal for practicing stylization. Try it with a variety of subjects. Eventually, stylization will be a natural part of your painting process.

Mirror, Mirror, on the Wall, Ernest Velardi. Simplification is a keynote to stylizing forms. This forceful opaque watercolor uses simplified forms and powerful value considerations.

Mountain Filigree, Robert E. Wood. Stylization and design control are evident in this clearly articulated composition of tree forms.

Transforming Subject Matter

Stylization is one effective way of transforming subject matter. Several other options are available in the pursuit of more dynamic images. One simple way is by selective arrangement or viewpoint. Viewing an ordinary subject from an unusual perspective can make it a more vital subject. Upward views stress elegance, ethereal qualities, and aspects of the spirit (Gothic cathedrals capitalize on sweeping vertical forms). Downward or aerial views flatten shapes and create overall patterns. Close-ups show intriguing surface textures and detailed information about some important segment. A side view might give us slight distortion and a compression of forms.

Abstracting from subject matter provides the most diversified range of possibilities. The emphasis here is to present the essence of a subject rather than its literal representation, and the abstraction may be slight or total. Wet-into-wet painting provides a ready approach to abstraction since it allows forms to be suggested and loosely stated. Deliberately working for abstract qualities, however, can be achieved by any painting method. Exaggeration and distortion for specific effects is one approach worthy of exploration.

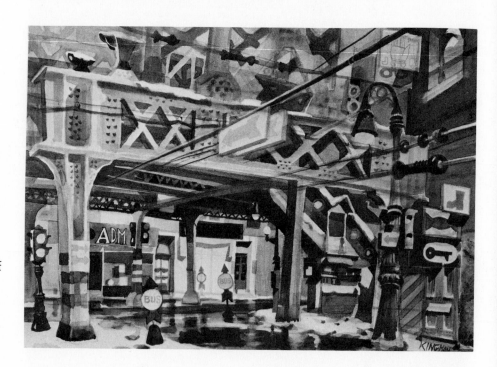

The El and Snow, Dong Kingman, collection of the Whitney Museum of American Art, New York. Using the signs, grid structure, and power lines of a city's elevated train line, Dong Kingman creates a striking design with powerful shapes and patterns.

The Great Red Dragon and the Woman Clothed with the Sun, William Blake, courtesy of the National Gallery of Art, Washington, D.C., Rosenwald Collection. In this watercolor by William Blake the power of strong images and dynamic composition test our imaginative faculties.

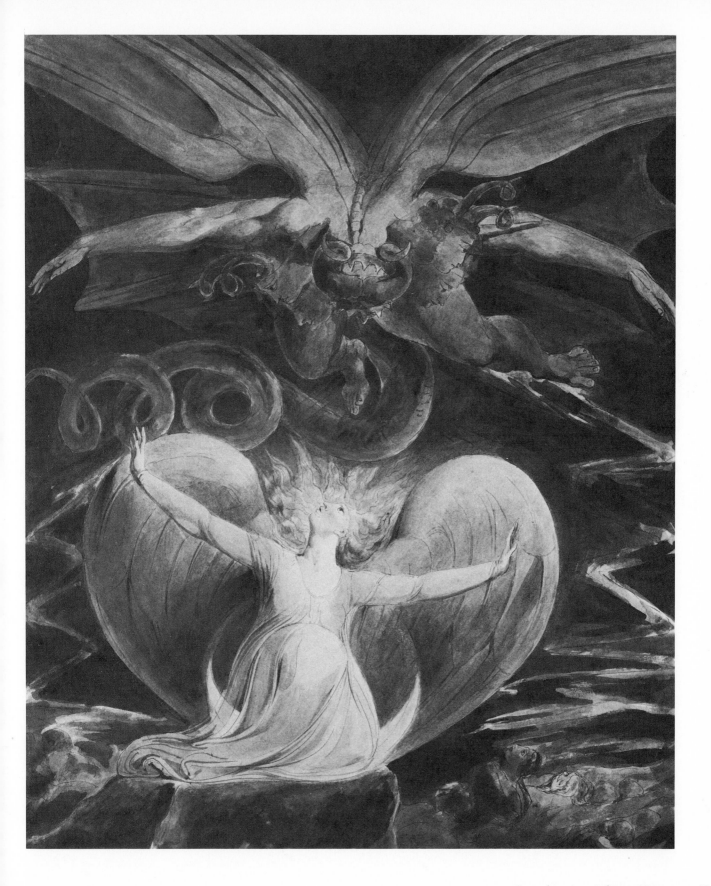

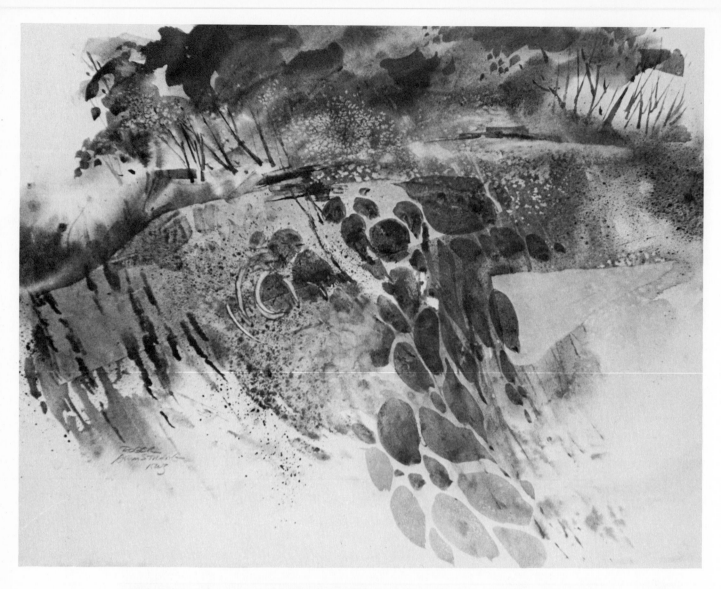

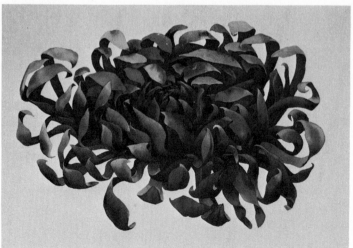

Hillside with Roots, Roger Armstrong, collection of the artist. The striking abstract qualities in this landscape are deliberately induced by the selection of patterned areas and lineal elements.

Chrysanthemum, James Fuller. By eliminating some of the parts of a flower, a stronger focus is placed on the beauty of the petal forms.

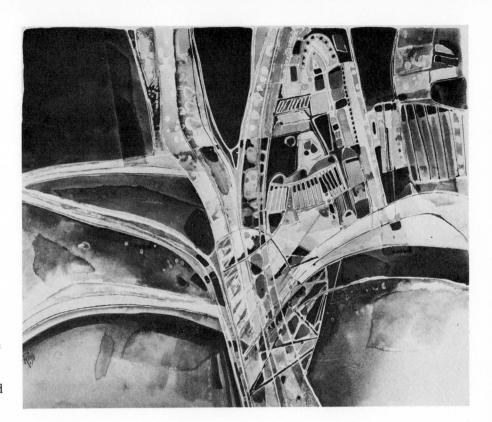

Three Rivers—Pittsburgh, Edward Reep, courtesy of Mr. and Mrs. Wade Hobgood. This aerial view of Pittsburgh puts the emphasis on a rich, flat pattern of uniquely designed shapes. Watercolor collage was used.

Try taking a subject form and interpreting it in various ways. Paint the thrust or direction of the form; simplify shapes; flatten forms; overlap and present several views simultaneously; exaggerate textures; use arbitrary color that differs drastically from usual appearances and stress the overall flat surface of the painting.

Subject matter can be transformed by putting it in unusual environments. Dong Kingman's imaginative cityscapes, for instance, often use delightful ambiguities of facts to create stimulating effects. Discovering whales floating down the river in a New York city scene is a provocative addition to the usual tugboats.

Partially obliterating shapes will add an air of mystery. The feeling of lost and found images is intriguing to the human mind. Try either painting partial suggestions of forms or lifting off parts with a sponge or brush.

Introducing a weather condition can transform subject matter. Fog, rain, wind, or blinding sun are worthy of use for visual effects. Try a few moonlit scenes or scenes with reduced or limited light. Transforming subject matter adds zest to painting and puts you in charge of the visual statement much like a director of film or stage who sets the scene, arranges the props, and selects the actors to put across the message.

Rearranging the Scene Robert E. Wood's watercolor *Ode to Carl Milles* (see below) is an excellent example of rearranging a scene. In this case, Wood took forms from Milles's sculpture (featured in a park in Stockholm, Sweden) and put them into his own composition.

A scene (or other subject matter) can be rearranged in two ways. One is to take significant aspects of the scene and invent a different setting for them. The other approach is to make arbitrary changes, including leaving things out; moving forms into new positions; adding items from other areas or from one's imagination; and modifying existing shapes, values, colors, or textures. A scene may also be flattened using little perspective; or extended with illusionary techniques such as perspective, shape sizes, and value range.

The point to remember is that we are not under strict orders to exactly duplicate what is in front of us. Much like a photographer, we should look for the best viewpoint, and then screen out extraneous shapes and details. In addition, we need to select what we feel is important and give ourselves the freedom of adding things that improve the overall effect. Even if onlookers are disturbed by our way of viewing and interpreting a scene, we should have the creative strength to make the changes that produce what we feel are more effective paintings.

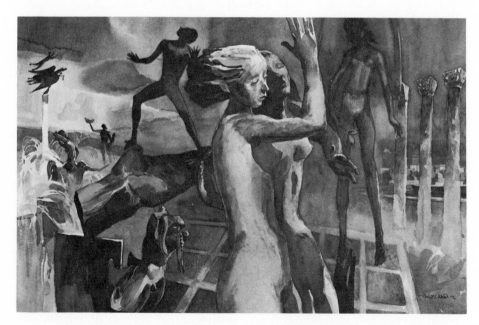

Ode to Carl Milles, Robert E. Wood. A new and challenging arrangement of the elements of a statue park in Stockholm gives this watercolor visual excitement and dramatic appeal.

Terminal Interior with a Red Line and *Delta Terminal,* Win Jones. These watercolors by Win Jones capture the essences of architectural form and figures with incisive lyrical qualities. The expert choice of scale and space combine with a mastery of watercolor handling to provide compositional elegance.

Composing the Message

The River, Lyonel Feininger, collection of the Worcester Art Museum, Worcester, Massachusetts. Strong vertical, horizontal, and diagonal thrusts break up the format in Lyonel Feininger's painting. The outer line reaffirms the format's shape and relates effectively to the shapes within.

The point in painting is to get our ideas across. Having something to say is, of course, the first step, but how we present our ideas determines the strength and success of the painting.

Composition gives us a way to present our ideas. To some people composition means slavish obedience to stiff rules or overly mechanical ways of organizing work. Actually, composing or arranging elements is the best way to give visual strength to imagery. It presents the challenge to be inventive within organizational guidelines. Even tight rules, however, are meant to be bent or modified.

Designing within the Format

The boundaries of our painting establish the format or area in which we work. The format can be a vertical or horizontal rectangle or a more unusual shape, such as a circle. We must be conscious of the prescribed area and break it into interesting smaller areas. To do this requires being acutely aware of how the shapes we use divide the space.

Most of us are aware of the deadliness of a shape placed exactly in the middle, since it monotonously breaks the format into equal sections. So it is wise to consciously shift shapes around until all of the parts of the composition create a pleasing, interesting arrangement. Consider how one shape interacts with neighboring shapes.

Extended Arms with Rectangle, Jane Wood. This intriguing watercolor uses a powerful vertical shape to break the format into strong simplified shapes. This shape is supported by muted background shapes and countered by the lateral thrust of the arms.

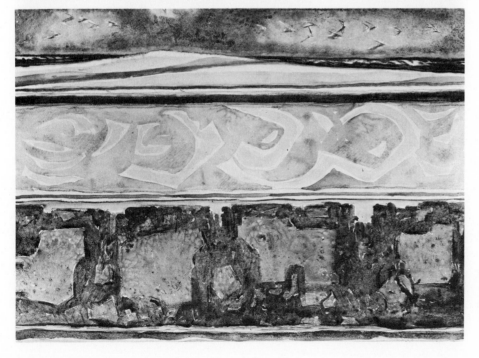

Sea Structure #15, Phil Dike, private collection. An excellent example of format division, this watercolor employs three major horizontal sections capably enriched by interacting shapes and textures.

Even slight modifications of placement can have a striking result in the formation of intriguing new background shapes (often referred to as negative shapes). Varying the sizes of shapes, including repeated shapes, also adds interest. How shapes conform to or oppose the format's overall direction also has a strong visual effect. Slanted or rotated shapes establish a feeling of movement, whereas shapes placed parallel to the format's base or sides establish a feeling of stability.

Planned Movement

Directing the viewer's way of seeing our visual efforts can assure that the message is read correctly. The trick is to provide paths of movement that focus the viewer's visual path. This planned movement involves shape placement, shape repetition, and the repeating of colors, values and areas of texture.

Placing shapes in a line will cause one's eye to move along that line. Overlapping shapes will move our eye inward. Shapes can be staggered and still retain a sense of movement as long as they are placed at consistent intervals. Hence, placement of shapes creates paths of movement that may be vertical, horizontal, diagonal, or curved.

The eye can also be directed by the placement of colors and values. Strong colors catch the eye; repeating color moves the eye from one area to another. Gradated color creates a slower movement. Similar effects are achieved with value. Judiciously placed darks and lights cause us to move our eyes along those placed values. As with color, transitional values, such as light to light-medium to dark-medium, will gradually move us through those areas.

Textures create interest in paintings. By selecting areas for texture you can reinforce the movement in your painting through the repetition of textures.

Moonduster. Movement sets the eye in motion. The sail shapes and the patterns of water and sky contribute to the way one views this painting.

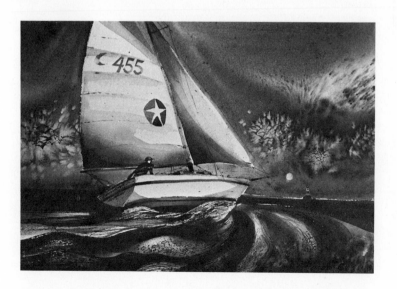

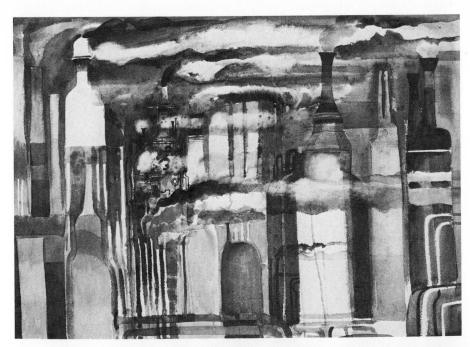

The Price of Energy #2. This watercolor has two major movements: vertical structural forms and lateral steam and smoke shapes.

Muddy Alligators, John Singer Sargent, collection of the Worcester Art Museum, Worcester, Massachusetts. The placement of these alligators moves the viewer's vision back into the painting from left to rear right. The repeated background trees form a path of lateral movement.

Cambridge King. A strong vertical shape is used for emphasis here. The major focal area is the head, with secondary ones in the body section, the small cross, and the lower helmet.

Points of Emphasis

A painting needs a point of emphasis. This can be added by the placement of shapes in the central area of the painting; by increasing the strength of the emphasized area with color and value contrast; and by giving the shape more interest in its irregularity, size, texture, or detail.

Usually, one area should dominate a work. It is called the center of interest or main focal point, and it is the most demanding section of the work. Here are the strongest contrasts and the most captivating shapes or part of a shape. It is suggested that you select an area near the center of the format as the main focal point. Since this area can lock in the attention of your viewer, it is desirable to have two or more subordinate areas of emphasis. Then the viewer's eye will bounce from one area of emphasis to another, creating visual movement.

Try using dominating shapes, sharper contrasts in value, and richer color (more intense and different from colors in adjacent areas) along with added detail to build points of emphasis.

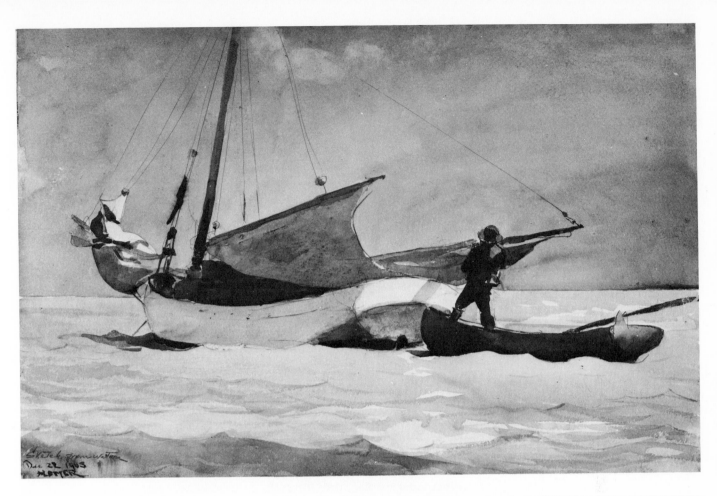

Stowing Sail, Bahamas, Winslow Homer, courtesy of the Art Institute of Chicago, collection of Mr. and Mrs. Martin A. Ryerson. A figure tends to dominate a painting. This strong simplified figure creates a focal point. The sails and major boat shape are logical secondary points of emphasis.

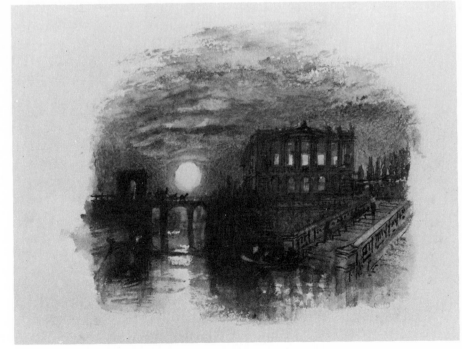

Padua Moonlight, William Turner, collection of the British Museum, London. This small watercolor demonstrates the use of a light source to create a strong focal point.

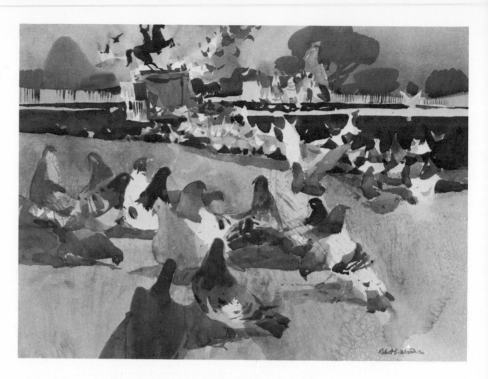

Pigeons of Jackson Square, Robert E. Wood. The impact in this painting comes from the intriguing way in which the pigeons have been arranged and modified.

Varied Repeats

If variety is the spice of life, spicing up our visual statements with variety should do wonders for adding appeal. Since shapes, colors, values, and textures need to be repeated to organize our work, it is recommended that repeats of these elements be varied in ways that increase interest and richness.

Shapes are easily modified in size, value, color, or texture. They can be changed further by altering the shape itself—by dropping part of it, by compressing it, or by stretching it.

Color can be changed by admixture of other colors, by increasing or decreasing intensity, or by modifying the value of the hue. Values are easily altered by going lighter or darker, and by the juxtaposition of values to increase or decrease contrast.

Textures can be used to describe forms and provide interest. They can be varied in size and strength, and used only in selected areas. Small, subtle textures can be contrasted with larger, more forceful effects. "Repeat with variety" is a good axiom. It means be more creative with the items that give our compositions both unity and variety.

Reinforcing Shapes

Because shapes often carry most of the load in conveying our ideas, the need for clarity and strength in shapes is evident. We can sometimes get shapes strong enough in the first washes, but we usually have to intensify them.

Several ways of improving the strength of a shape can be employed. One easy method is to increase contrast. This can be achieved either

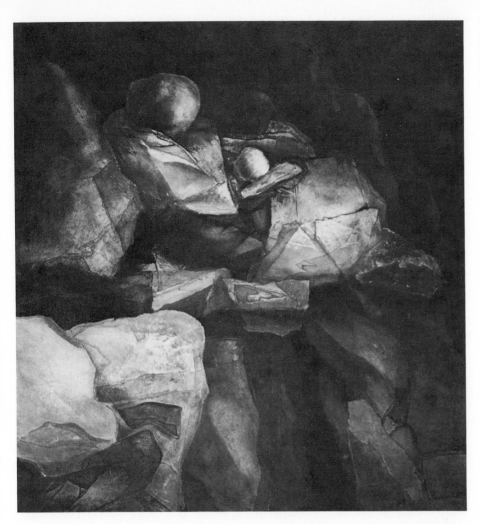

Two near the Abyss, Alexander Nepote, collection of Lytton Savings and Loan Association of Los Angeles. Powerful shapes are created by contrast. The visual strength is achieved through the juxtaposition of significant edges and controlled textures.

by making the shape stronger in value than its background, or by increasing the contrast with the background to make the shape more forceful. Light backgrounds call for darker shapes and vice versa.

The edges of shapes can be clarified either totally or partially. By increasing the value of the edge or of its adjacent background, we make the edge important. The effect is certainly more interesting if just sections of the edges are reinforced rather than all the edges.

If we add more color to the shape we further glamorize it. This is often done by overglazing with compatible colors that enhance the color underneath. As with edges, it may be preferable to increase the strength of the color in certain sections rather than over the total area.

Adding texture and line also gives the shape more emphasis. This enriching process of textural additions is often done in finalizing work, but discretion is advocated. A little texture, effectively applied, does wonders; too much can easily spoil the final result.

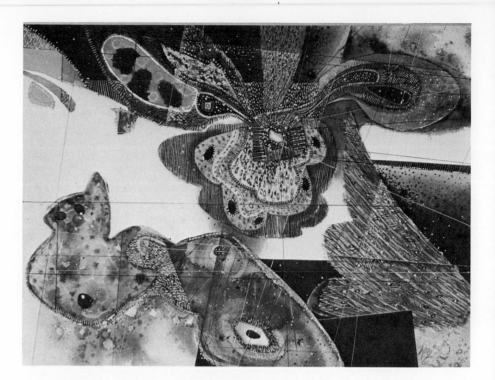

Circumstance, Edward Reep, collection of Mr. and Mrs. Al Whitehurst. Value, color, and textural enrichment have been competently controlled in this unique composition. The relief provided by unadorned space gives a judicious contrast to the more lively shapes.

Enrichment

Adding the final touches on a painting might be termed enrichment. It is often the final touches that make or break a watercolor.

Overworking usually results in muddiness and loss of transparency. Understating conveys a lack of conviction or a weak presentation. What is needed is that happy medium where the last strokes count. A good rule is to stop painting when you can't make any more decisions. Painting without conscious thought as to the effect of the additions will undoubtedly create havoc in an otherwise promising piece of work.

Much of our finalizing is done to improve weaker areas. Whereas the initial part of a painting is done with more speed and a concern for general effects, the last part is more reflective and judgmental.

Details added to existing shapes, such as a few lines or areas of texture, assist the enrichment process. They add to the information about a form and provide more visual excitement.

A few additional darks often give the final visual punch; they can be used to increase the strength of focal points. Selective glazes of thin color are instrumental in adding that final touch of color to a surface that lacks interest. These same glazes can be used to enhance paths of movement that lack sufficient power. In all overpainting a light touch is desirable. Try not to disturb underwashes by overly vigorous brushwork. Be attuned to what is underneath and what is going over. When in doubt, testing the effect on a separate sheet of paper will provide concrete answers.

Fresh Air, Winslow Homer, courtesy of The Brooklyn Museum, Dick S. Ramsay Fund. Added details and reinforced washes give visual interest to this figure. The fabric description enhances the feeling of atmosphere as well as information on the woman's attire.

In this enrichment and finalizing process, back off from your work to judge it from a viewer's distance (5' to 10', depending on size). When the last stroke goes down, the painting is complete — once you add your signature in an appropriate spot. You may want to review the work at a later date and make a modification or two, or you may stick with your decision as to its personally satisfying condition.

Painting is a building process that has a logical beginning and ending. Following these steps will be somewhat consciously forced at first, but with experience they will flow in a natural sequence. Eventually, the brush will quit at the most propitious moment.

Color and Value Control

The watercolorist who has developed a sensibility for color and a firm control over the effects of dark and light values is in a good position to paint with conviction and expressiveness. These two design elements have a tremendous impact on the artist's effectiveness with paint and paper. Working toward this kind of control should be paramount in the minds of all students of this medium, and keeping this mastery, a concern for practicing watercolorists.

In using color a number of concerns affect us: how we choose color; how we put colors together; and conveying color moods and intensities.

Selection of Color
Choices of color for painting may be quite arbitrary, or merely reflective of subject matter. An artist may paint the sky its usual blue or endow it with vibrant reds and oranges. If we are just repeating the color in front of our vision, then color selection is already determined by that subject matter. And much can be said for learning to paint the colors we perceive with some degree of accuracy. The problem is that rarely, if ever, can we duplicate the diverse color nuances of nature with our limited palettes. Furthermore, as human beings, we respond quite differently to color in our environment. Our emotional makeups vary, and even this has an impact on color awareness.

Even when painting representationally we should key in our personal sensibilities and temper them with an understanding of how color pigments translate thoughts and images. In general, you will find most artists restrict hue (color) to achieve effects. This limitation is very wise.

A painting can have one dominant color that pervades the total work. This color is usually modified so that it gives the appearance of many colors. Hence a green can vary from the yellow range through the blue range. Making a limited number of colors do most of the work provides cohesiveness. As the color range is extended it is desirable to make the necessary links between hues so that color organization prevails.

Big Sur Set #6, Phil Dike. A limited palette portrays this slice of California landscape in which the provocative patterns of birds, clouds, and rock forms dominate. Strong unity is achieved by restricted color usage.

Land Mass, 35" x 56", Sylvia Glass, courtesy of the Orlando Gallery, Los Angeles, California. In this large abstract, textural passages energize large fields of color reminiscent of nature's surfaces. Subtle cool areas in grayed blues relieve the more intense warm areas of color. This subdued contrast of color still retains an overall unity.

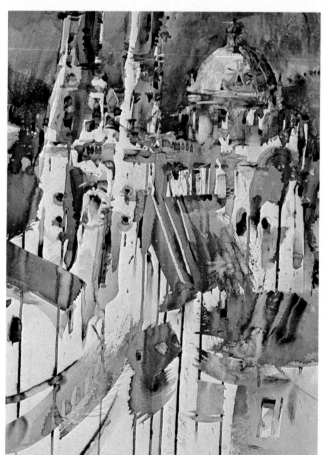

Taxco, Miles Batt. For absolute color unity, the monochromatic scheme can't be beat. The dark and light values of brown carry a strong message of Mexican building forms.

Weathered Piece of Glass, Lee Weiss. This painting superbly demonstrates total color and value control to express nature's subtle surfaces and forms.

Color Schemes

A monochromatic scheme based on total commitment to one color will achieve maximum harmony, with the interest coming from the manipulation of values. More interesting in achieving unifying effects is the analogous scheme that keys in related colors. Using red-orange, red, and red-violet would assure a color scheme that is unified with some hue variety. This type of scheme can be stretched by including all warm colors (yellows, oranges, reds, and violets) or all cools (blues, greens, and blue-violets). In general, analogous color schemes are the answer to most questions about choice of color scheme. They offer richness and harmony at the same time. Even when using contrasting colors, a stronger emphasis on analogous colors can achieve painting unity.

Monochromatic and analogous schemes do give a desirable harmony, but they lack the visual punch often needed for color excitement. For this more adventurous involvement we need contrasting colors or a complementary scheme. The word complementary means "serving to add to or complete." With color, this refers to intensifying an adjacent color with one opposite it on the color wheel. A red placed next to a green makes both colors appear brighter. These complementary pairs are yellow/violet, blue/orange, and red/green. Opposites also include yellow-green/red-violet, yellow-orange/blue-violet, and red-orange/blue-green. Some experimentation with these complements quickly demonstrates the power of opposites to raise the intensity level of color. In painting, complements are generally used for accents and emphasis. Thus, a basically green painting can be enhanced by careful placement of small areas of reds. When we want to make something more important through color, a complementary scheme is an excellent solution.

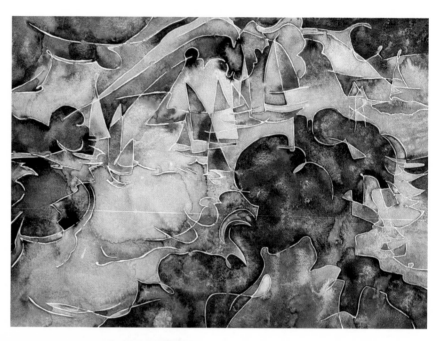

Jetty Line Dancer, Miles Batt. A variety of rhythmic lines and shapes capture our interest here. The complementary colors of green and red judiciously reinforce the design.

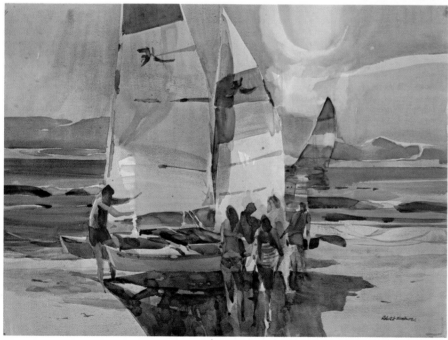

Gulf Breeze Hobie Cat, Robert E. Wood. For projecting rich color contrasts, the careful application of opposite hues can give a painting an energetic look. This sunny beachscape delights the eye with red/green and blue/orange combinations.

Cloud Light Series — Storm Lifting,
Joan Foth. Here the artist used com-
plementary colors to contrast the
moist expressive sky with the dry
earth tones. The complementary color
bands at the top and bottom of the
work add emotional impact to this
strong yet sensitive painting.

Color Mood

Color is a powerful agent in expressing mood. By careful use of color we can create moods that greatly enhance the communicative impact of our paintings.

Deep blues and violets evoke mysterious qualities; bright reds display intense energy. Greens are generally quiet, yellow is vibrant. If a group of trees should seem foreboding, they can be painted in dark blues and blue violets. The same trees mantled in reds and oranges would seem joyous.

Some colors, particularly mixed ones in certain combinations, have exotic qualities. The combination of bright color and mixed colors gives the type of rich offering we associate with tropical climates, intriguing costumed figures, and lush vegetation.

Mood should be interjected early in the painting process so that its effect is pervasive. The first color washes can easily set forth the desired mood, whether mysterious, vibrant, quiet, or joyous. Color mood enhanced by values and the appropriate staging of subject matter will bring out a vitality that expressive painting requires.

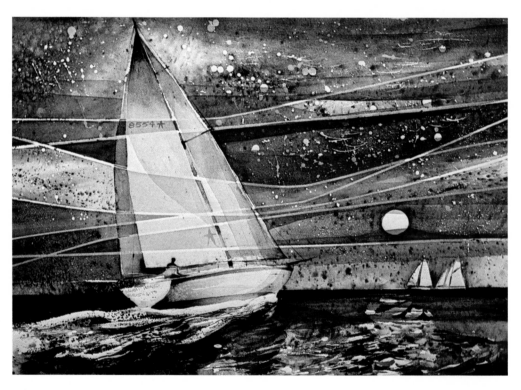

Warm Wind, Cool Sea. Color mood is achieved when selected hues and values impart the essences of a subject. Here deep blues and blue-violets set the mood of an evening sail.

Morning After, Nick Brigante, from
the Burnt Mountain Series. Deep rich
values and hints of color carry the
impact of dramatic mood in this
watercolor.

Color Intensity and Suppression

Juxtaposed complementary colors give us the ultimate in color intensity, but other factors control the intensity of colors. Brightness is determined by the amount of dilution, its admixture with other colors, and its placement on top of other colors. The most intense colors are those of minimum dilution on white paper, or recharged color in wet washes. Suppression or dulling occurs with the mixture of complements and successive color overlays.

If a green is too bright, a little red (its opposite or complement) added to the paint will mute it. Alternatively, a dry green wash can be overlaid with a transparent red wash for a similar result.

A painting often achieves its ultimate potency in color when there is an appropriate balance of intense and suppressed color.

Glazing also affects the intensity of colors. To ascertain the glazing capability of colors, make a grid using all of the colors in the palette. Paint medium-strength color stripes of each color. After these dry overlay stripes of the same colors in the opposite direction. See page 26 for more information on glazing.

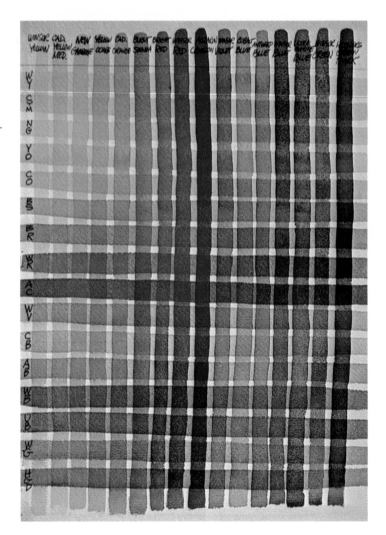

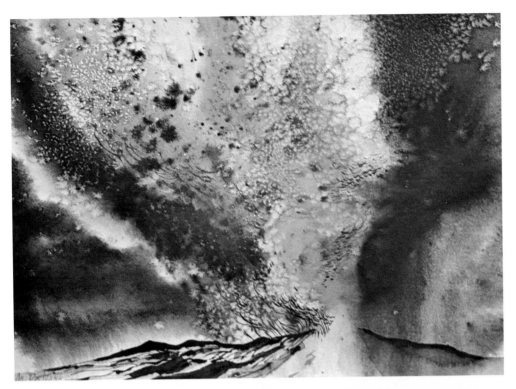

When a subject requires visual punch, then intense colors are called upon to help deliver the message. This volcanic study is a warm-up for a series on this subject theme. Bright reds, oranges, and blues are used at nearly full strength.

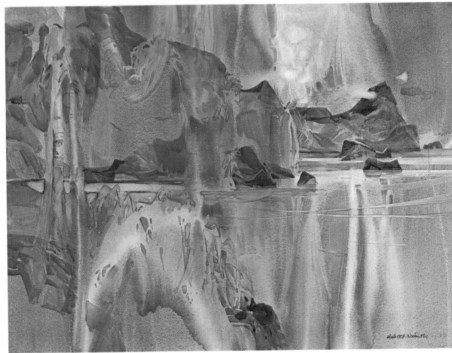

Tropical Jewels, Robert E. Wood, collection of Joe Messner. The orchestration of intense color and grayed passages establish a powerful mood in this stimulating watercolor.

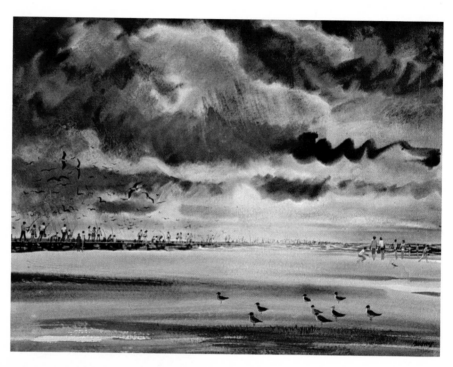

South Jetty, Port Aransas, Michael Frary. Only a hint of suppressed color is used in dealing with this seascape.

Indifferent Love, Miles Batt. Similar suppressed effects create a pervasive mood by muting color in this unique subject treatment.

Wyoming Morning, Morten E. Solberg, private collection. This artist used rich intense browns against greyed blues to bring attention to the deer forms. Value and contrasts are expertly handled to further enrich the statement.

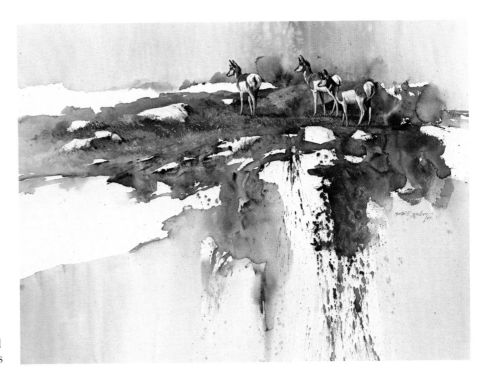

Rex Begonia, Dorte Christjansen. Restricted color amplified with value and texture gives a convincing view of this plant form.

Value Range Value refers to the lightness or darkness of a color. Yellow is a light-valued color and blue provides a range of deep values. Usually, we can mix a good range of value with most colors by color dilution. Full-strength color gives the deepest values and lesser values occur as we weaken color with water. Most colors can be easily broken down into light, medium, and dark values. These often can be expanded to values in the light-medium and dark-medium range. With the darker colors the range has an expanded possibility with potentials for nine or ten distinct value steps.

Neighborhood Watch, Tom Wooldridge. An excellent example of suppressed color is this painting which achieves its strength through crisp value contrasts and textures.

Chaouen, Paul M. Souza, private collection. A wide range of values has been utilized to depict this complex figure arrangement. Background figures have been judiciously downplayed in value and color intensity to allow forward figures to dominate.

Defining Form with Value

Value clarifies form. With washes of varying values one can describe a shape or form by the manipulation of value. Round forms require value gradations, easily achieved by gradually diluting a wash as it moves around a form.

Generally, light washes are used to state forward areas or top-lighted surfaces, and deeper values are used to define recesses or areas deprived of light. The more gradual the curve, the more gradated the wash needs to be.

Angular forms are best portrayed with contrasting values painted in a hard-edged manner. A faceted rock form may use as many as five or more values to show its shape.

Values are also useful to separate areas and to imply depth. Lighter values suggest distance. In shallow space contrast alone can be sufficient—light against dark or dark against light. Gradations of value can also be used to move the eye along a shape—light to dark or dark to light.

A cast shadow helps to explain a form since the shadow reflects the shape. A shadow cast on a form helps to define the contour of the form.

A good value range is often a necessity to make forms read accurately. It is particularly important to step up contrasts of value for points of emphasis and significant edges, and to increase a sense of movement.

The Shopper, Paul M. Souza, private collection. In defining forms, value control ensures successful clarification of subject matter. This artist expertly manipulates values to make forms convincing.

Both color and value contrasts are beautifully coordinated in this painting by Gerald Brommer of Greek scenery. Blue sky against warm browns and oranges set up appropriate color intensities.

Contrasts for Effect

Along with color, value establishes a mood for a painting. Dark paintings have a mysterious, dramatic air about them; light value paintings capture a more ethereal effect.

Contrasts of values strengthen forms. What color may not be able to do to clarify shapes, value can assure. As a painting moves to conclusion the use of values to increase contrasts and enrichment is important. Values sharpen shapes, clarify paths of movement, add interest through pattern of value, and reinforce the mood of the subject.

Value Organization

Values should be balanced in a painting while contributing to the path of eye movement. If the darks in a work are not placed with consideration for each other, then unification is weakened. Strong contrasts used in a single area call for the use of other darks, often of lesser power, in other parts of the work.

Darks or lights can be used to move the eye throughout a painting when one type of value leads to another either by its position or through transitional washes. This technique is extremely useful in bringing attention to major focal points.

Small compositional sketches done completely in values are excellent to prep oneself for a painting. These shorthand studies allow us to try numerous possibilities and instill in us the confidence to use value effectively.

The Moonskein, Mary Jane Kieffer. A provocative mood is achieved in this watercolor and ink painting by deep, mysterious greens heightened with flicks of yellow.

Venice, Ca. Remembered 1938, Lee J. Wexler. An effectively employed range of values moves our eye throughout this painting. The pier structure dominates because of its sharp contrast with the background area.

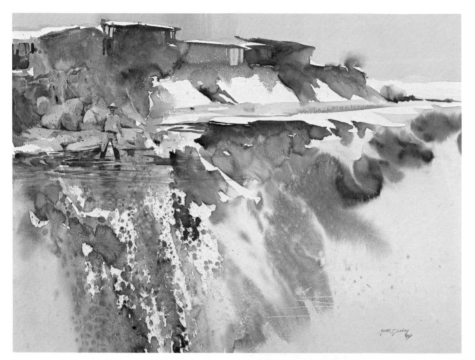

Near Cody, Morten E. Solberg. Value is used here to organize pictorial movement. The figure dominates, but other parts of the composition are skillfully linked by repeated deep values.

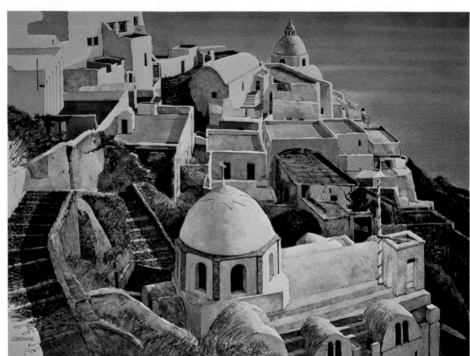

The artist, Gerald Brommer, has used limited color but added a rich range of values to clarify and enhance these Greek architectural forms.

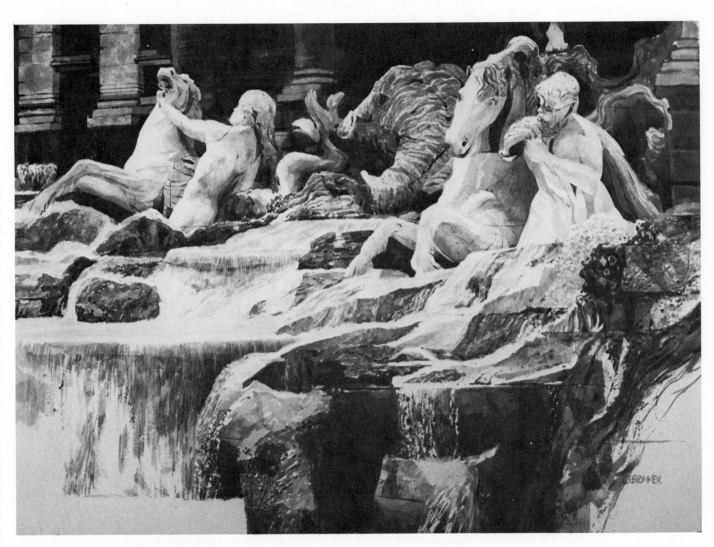

Trevi Fountain, Gerald F. Brommer. This is a strong example of reinforced shapes. Fountain sculpture has been expertly defined against contrasting background and adjacent areas. Water textures add more intrigue.

Emphasizing the Subject

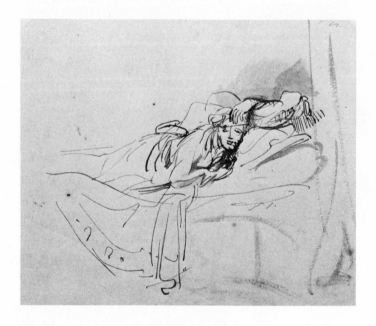

Saskia Lying in Bed, Rembrandt van Ryn, courtesy of the National Gallery of Art, Washington, D.C., Ailsa Melton Bruce Fund. This pen and wash study of a reclining figure masterfully selects the essentials of form and space using a minimum of line and value.

Discovering Essentials

It is often said that what you leave out of a painting is as important as what you put in. Overstatement is a trap to avoid; something should be left for the viewer to add. The missing details kindle the imagination and capture the viewer's interest. In this way the viewer can participate in your creative work.

In order to accurately describe a subject when details are left out, it is important to deal with the essentials or essences. These are the significant qualities that pervade the subject. For instance, a sweep of clouds, the vertical movement of a stand of trees, the angularity in a figure, or the fragility of flowers may be an essential ingredient in a painting.

In approaching any subject we rely on both sight and feeling. Vision gives us information about shape, size, position, space, and myriad details. Our sensibilities or feelings toward the subject determine the focusing device. We are attracted to the essentials that animate the subject and our reactions to these essentials form our initial reason for painting the subject. Thus, we should strive to capture these essentials in paint: the horizontal movement of a field, the upward thrust of a mountainside, or the dancing patterns of light and dark on water surfaces.

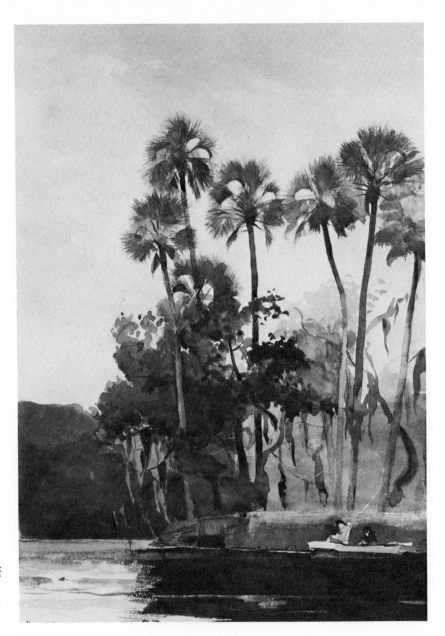

Homosassa River, 1904, Winslow Homer, courtesy of The Brooklyn Museum. Winslow Homer grasped essentials with deliberate restraint. He emphasized the important elements of tree forms, water mass and figures in a boat, thus giving us a captivating depiction of a Southern environment.

Discovering essentials requires the openness to feel deeply about our subjects. It means looking past extraneous details and surface qualities. Using essentials effectively requires us to deliberately restrain that itching desire to render every object, often in a piecemeal fashion.

Some practice sketchbook sessions on painting essentials can do wonders for pointing us in the right direction. Try painting the relationships of shapes, or developing a sequence of darks and lights, or just painting general movements that reflect the nature of the subject. Perhaps the best way is to learn to simplify.

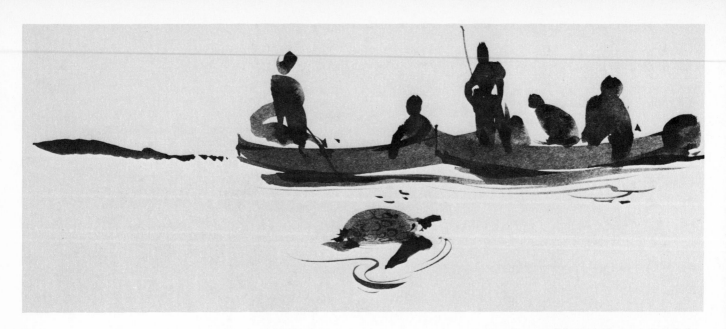

Quick, simplified strokes captured the essence of turtle fishermen at work in this watercolor study by Bill Pajaud.

Simplification

By simplifying we increase the visual impact of our ideas. Stating our message clearly directs the viewer to what we feel is important. Simplification requires removing the visual clutter that can adorn any subject. One does not have to paint each tile on a roof to imply a tiled roof, or put in all the folds of fabric to clarify the action of a clothed figure.

We can simplify by painting the major shapes, the important values, the significant textures, the colors that fit the forms (often reduced in number or restricted for effect), and by adding details judiciously. Shapes are simpler when seen as masses. Try squinting when looking at subjects so that details are lost and the general image dominates. The form of a heavy, foliated tree is quite simple to capture when seen as a silhouette. If we can start with these simplified major shapes, it is relatively easy to add to these the major values and the essential details. Simplification also opens up approaches to design and improvisation. Once the clutter goes, we can see the design images—the links between forms and how they interact with each other.

Simplification is greatly expedited with a large brush. Many watercolorists paint most of their work with sizable brushes (some 2″ to 3″ wide). For simplification it is certainly preferable to work initially with the largest brush available, only reaching for the small brush at the last moment.

Practice painting with large brushes using the silhouetted shapes of complex forms, and suggesting subject matter simply. These skills will add immeasurably to your mastery of watercolor.

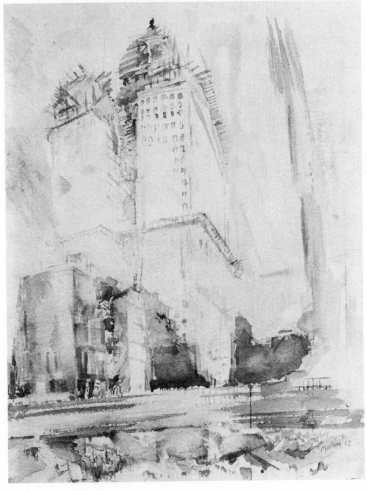

Old Houses, Charles Demuth, courtesy of the Los Angeles County Art Museum, collection of Mr. and Mrs. William Preston Harrison. *Woolworth Building #29,* John Marin, courtesy of the National Gallery of Art, Washington, D.C., gift of Eugene and Agnes E. Meyer. Charles Demuth and John Marin took complicated subjects and reduced them to the essential elements by implying information. Marin's skyscrapers show few windows; Demuth eliminated detail on the house forms in favor of a flat, designed look.

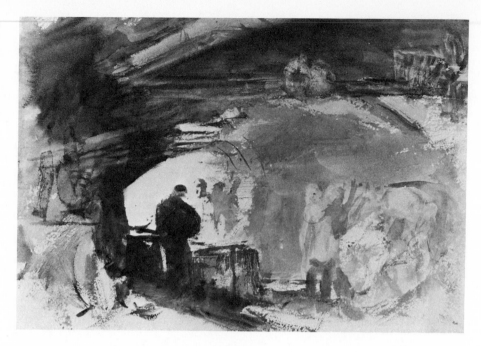

A Blacksmith's Shop, William Turner, courtesy of the British Museum, London. Shallow space is expertly created in this workshop scene. Value control and reduced images suggest the restricted environment.

Using Space Within the painting format is a great potential for space manipulation. A perfectly flat painting with no space implied is sometimes preferable; nonobjective work requires this type of surface integrity where shapes, colors, and textures can be seen on one flat plane. Other work, whether representational or abstract, usually deals with space as an essential element.

If the space is to be relatively shallow, as in most still lifes and close-up views, then space manipulation will tend to be subtle. It can be achieved by such devices as overlapping shapes, gradations of values, sharpness and fuzziness of forms, and the use of color intensity.

When space is used in a broad manner, as in open landscapes, then more exaggerated effects are required. Such large spatial effects require a careful assessment of the sizes of forms, their position on the format (lower being close and upper, distant), an attention to the brightness and grayness of colors that advance or recede, and the lineal effects we associate with perspective, such as converging lines as they recede in space.

Space is a fascinating element to deal with in painting. If used to extremes, it can be detrimental. Severe perspective tends to leave a viewer back on the horizon at a particular vanishing point, with no return to the essentials. In spatial planning, it is wise to keep space within reasonable bounds where it serves the essentials of the subject matter. Think of the space needed to manipulate the shapes and to move the eye with ease. Often, some flattening of space is desirable to contain our visual ideas in a more compact composition. Painters

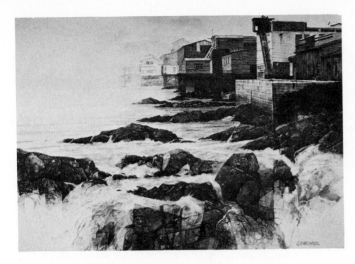

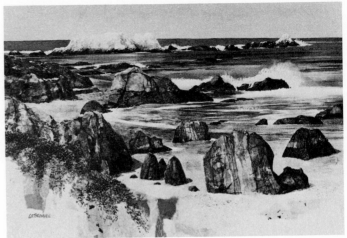

Gerald Brommer has shown us excellent use of space in these two landscapes. The devices used include overlapping, placement within the format, perspective, and detailed areas versus simplified forms.

often overlap shapes and adjust value and color to achieve spatial effects. This avoids the empty, deep-hole appearance that long perspective views engender.

In general, space is suggested by the following devices and their numerous variations. Experimentation with these approaches will point out the best usages.

Overlapping shapes immediately creates space. Be sure that closer shapes are lower on the painting (closer to the baseline) than those behind.

Strong colors, particularly warm colors like red, orange, and yellow, tend to advance, whereas weaker colors, especially cool colors like blue and green, tend to recede.

Likewise, strong values suggest proximity while lighter ones suggest distance.

Gradations create transitional space. The more detailed a form the closer it will appear; silhouetted or less completely rendered forms appear to be farther away.

Slanted shapes move from the larger, closer end to the smaller, more distant end. This spatial effect is related to lineal perspective where shapes are seen as getting progressively smaller as they disappear in space.

Size is one of the most effective ways of creating space. Two similar figures, one large and one small, will immediately produce the illusion of distance.

Human figures are excellent for moving one's eye in a composition. They afford a scaling device for judging the size and distance of other forms.

Space is an important element in creating the environment for our subject matter. How we utilize the foregrounds, middlegrounds, and backgrounds will determine whether or not our compositions are clear, interesting and effective.

Designed Shapes and Arrangements

A natural extension of representational work is exploring the excitement of design and imaginative arrangements. Designing a shape means altering its natural appearance for a desired effect. Cartoons, fashion design, and fantasy illustration are obvious examples of the use of designed shapes.

Simplification is a good starting point for intensifying a shape. With the extraneous details eliminated, the shape's character can be clearly seen, and from this starting point can be altered to increase its visual impact. Stretching or expanding a shape exploits its character in a positive way. This change may be slight or exaggerated. Figures can exceed the usual seven-and-a-half-heads-high standard. Landscape elements can be modified to increase excitement. Tree forms can be taller, lean in a more dramatic way, be tailored and stylized, or be clustered into one large overall shape. Rocks can be arranged and pointed in desired directions. Mountains may be made more massive or broken up into formations of faceted surfaces. All shapes can be enriched in suitable designed patterns. This enrichment may consist of dark and light patterns, lineal treatments, or planned textures.

The color of a shape can also be altered for effect. The color can radically differ from the original hue, be intensified or suppressed, be gradated to create movement or pattern, or be overlaid to produce intriguing transparencies.

In arranging designed shapes, consider positioning them to bring out the important focal points; placing them to create paths of movement; contrasting grouped shapes against single units; and varying the sizes for interest and spatial effects.

Designing requires deliberately moving away from the obvious to more personal, imaginative solutions.

Landscape Subjects

Landscape painting on location and watercolors are made for each other. The equipment is light, the drying time reasonable, and the technical capabilities ideally suited. You could start with your backyard or neighborhood and eventually end up painting in a foreign land. So much is accessible that a career can be devoted to painting landscapes, as many watercolorists do. There are so many suitable sites that a watercolorist should start with what is readily at hand and not miles down the road. Once a location has been selected, you must decide how to get the most out of the experience. If the artistic vision is well tuned, then several paintings will be possible at one location. These may use several viewpoints of one location, or different views of the surrounding area.

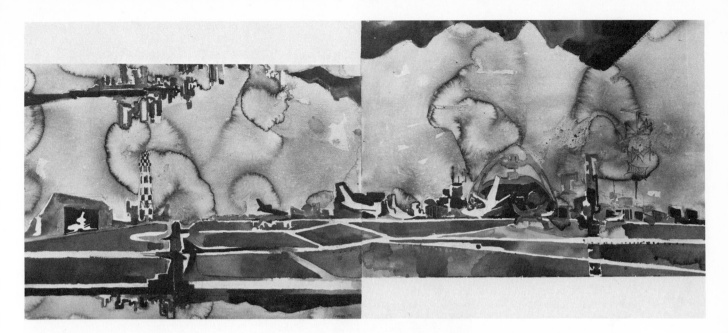

L.A.X., Keith Crown. These two abutted watercolors establish a striking format for the designed shapes of the Los Angeles Airport.

Evening and the Morning, Ernest Velardi. Overlapping and value contrasts create an inviting feeling of space, even though this composition is kept on a relatively flat plane.

Back to the Nest, Michael Frary, private collection. Positive and negative shapes and vertical and horizontal movements are used in composing this lyrical view of nature.

If time is limited, it is important to paint as soon as possible. Usually, a few quick preliminary sketches to feel out the compositional possibilities are desirable although the more adventurous painter may plunge in directly without sketching. In any event, it is best to avoid oversketching so that creative energies are not drained or interest diminished.

Some watercolorists like to block in the intended composition with a light pencil or diluted brush line. If a subject is complex, the lines help guide the painter. Other artists prefer to work directly without guidelines. Disposing of the line encourages a more free-wheeling, expressive approach and more freedom to manipulate the images that start to form.

The big brush/large area approach is also encouraged. Once the major shapes are in they suggest solutions for the smaller pieces. Planning eye movement throughout the painting and linking the major masses assures a more cohesive composition. Try to stress the major movements, such as the diagonal thrust of a sky area or the inward sweep of land forms. Into these staged areas can be placed the landscape information: trees, rocks, buildings, figures, etc. Work as generally as possible, building forms and strengthening values so that the main intentions are reinforced. Painting executed outdoors can turn out weak if color and value are not kept at appropriate intensity and strength. On bright days white paper weakens our eyes and we

Canyon de Chelly Refuge, Gerald F. Brommer. This grand view of a complex landscape subject has been eloquently captured by the use of contrasts in scale, lateral and vertical movements, and an effective range of values.

George James has used the close-up view to increase the impact in this intriguing watercolor of a refuse site.

consequently understate the colors considerably. To counter this, washes should be recharged with color and value to ensure adequate saturation.

Outdoor painting seems to follow a pattern. Initially, big washes are laid down and the major elements are stages. Next follows reinforcement of elements and the insertion of major forms. This stage clarifies the structure of the painting. The final stage is the painting of needed details, textures, and lineal elements. It is a time to slow down and carefully assess each added stroke. Standing back from the work is helpful to objectively judge the painting's readability and richness. The final strokes should strengthen and enrich. Many landscapists prefer to finish their work in their studios. It is important that this finishing be minor and that the ambience and visual impact of the landscape be registered in the work at the site.

Field trips to a variety of challenging subjects are extremely valuable in charging our creative batteries. If the juices are running dry, try some outdoor painting.

Using the Figure

Figure painting is certainly demanding. Inexperienced painters often avoid the figure and restrict themselves to easier subjects. This seems unfortunate because the human element in our lives is extremely important and can add unusual interest to paintings. Usually, experience in drawing figures, either by private sketchbook activity or through formal life-drawing classes, will restore the needed confidence. Furthermore, in watercolor painting a simple figure statement is often quite satisfactory.

The trunk of the figure is a good starting point, going from shoulders to hips. From this mass, leg forms are readily attached, as are the arms, neck, and head. Feet and hands complete the process of moving from large to small. The same approach can be used in analyzing values. Paint the major value separations that distinguish front from side on the major forms (trunk and legs) and the minor ones (arms and head). Usually, two or three clear-cut values will chisel out the general form. Deeper values can be used to push form back or in, and light values will state forward areas.

Once the form has been generally stated, then modifications and details can be added. Above all, try to suggest rather than to render. Explore a variety of figure positions to gain a mastery of the figure in action. After single-figure studies, groups should be tried. Along with painting positive forms, investigate the possibilities of carving out negative figure shapes by painting around figure shapes. This process is particularly helpful in adding figures to a background area by using a deeper value around a figure form.

In Switzerland, John Singer Sargent, courtesy of The Brooklyn Museum. One of America's great figure painters demonstrates his expertise in this reclining figure sketch in watercolor.

Coot Hunter, Andrew Wyeth, courtesy of the Art Institute of Chicago. The freshness of watercolor is displayed here as the artist captures the essentials of a figure in a landscape setting. Simple, direct washes and minimal detail heighten the overall impression.

Shooting the Rapids, Winslow Homer, courtesy of The Brooklyn Museum. Note the effectiveness of silhouette shapes and chiseled values to create convincing figure forms.

Figures are excellent for establishing scale in a landscape or interjecting a sense of movement or drama. Stylizing figures by simplifying, elongating, or distorting them for effect can increase the impact of a figure form. Costumes or exotic garb can also provide a decorative quality.

Figure competency comes with constant practice and application. This important subject matter should be well in hand for use when needed.

Jane, Robert E. Wood, collection of the artist. A sureness of the structure of the figure enables the artist to paint with concerns of aesthetics and pictorial interest. This watercolor is a fine expression of form skillfully handled in carefully considered values and appropriate areas of emphasis.

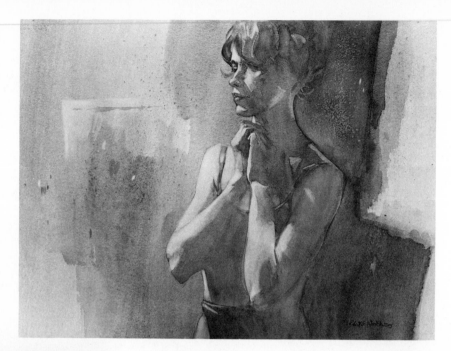

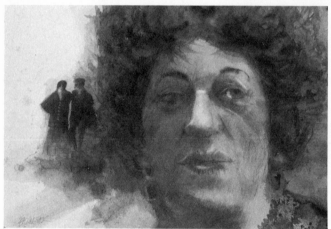

Rosie and Harry, Lee J. Wexler.

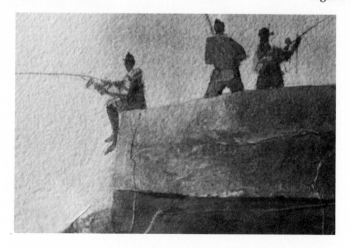

Figure study, Joe Mugnaini.

Figures in a painting detail, Gerald F. Brommer.

These figures illustrate several ways of treating the human form. Each artist has a unique way of expressing the figure.

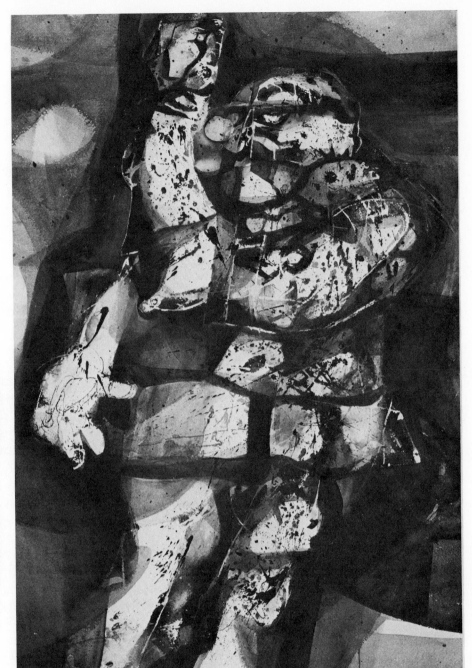

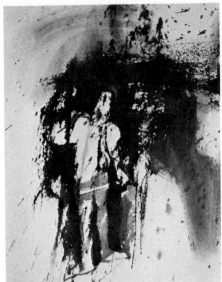

Figure in a painting detail.

The Amulet. This abstracted figure
shape has been fragmented into
shapes associated with knights and ar-
mor. Exaggeration and distortion have
been used to accent emotional aspects.

Exploring in Depth

One way to extend ourselves creatively is to paint in series or to explore a subject in depth. We are all fascinated by particular subjects. These may be simple forms such as the plant life around the garden, or the way light reacts on glass surfaces; or they may be more complex, as in personal reactions to social issues, views of complicated environmental scenes, or the interplay of abstract forms in a composition.

Instead of one-of-a-kind painting in which we move from one subject to another, in-depth exploration requires many paintings focused on a single subject or idea. The purpose is to extract as much as possible from a theme. This might mean painting an object or scene from different views, or with variations in colors, values, or textural surfaces. This procedure gives us a more complete understanding of the forms we are painting. It also reveals the more significant views of a subject through probing visual inspection. Even painting a subject from different eye levels increases the visual excitement. Below eye level, oblique angles, and top views all are capable of producing a more stimulating composition.

Along with painting the observable, it may be possible to break down a subject (either physically or imaginatively) to reveal interior views or fragmentary aspects of a subject. Or a three-dimensional subject can be treated as two-dimensional shapes that are juggled into a variety of arrangements. Along with the flattening process, shapes can be designed in the ways pointed out earlier in this chapter.

The world of ideas, social issues, and personal concerns and feelings all provide potentials for challenging, in-depth exploration. For a painter who feels strongly about pollution or the crises of violence and war, the investigation of such themes in paint broadens creative energies and communicates these concerns to others. The artist who explores the deteriorating facades of city life can also project his or her concerns and insights in visual form for others to consider. Another artist may prefer to look more intensely at the uplifting qualities of nature and reveal those aesthetic insights.

Work tends to be far more significant when explored in depth, whether the subject is a solitary rose, industrial smokestacks, rock forms in streambeds, or the flow of abstract shapes in nonobjective compositions.

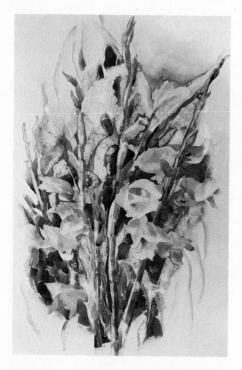

Gladioli, Flower Study No. 4, Charles Demuth, courtesy of the Art Institute of Chicago. Charles Demuth often chose to paint in series, whether it was various city environments or the intricacies of flowers.

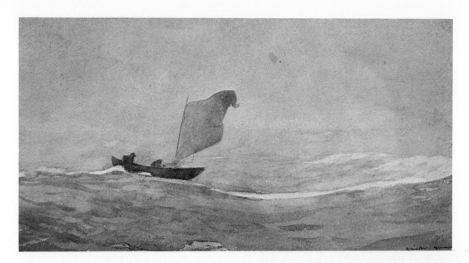

Blown Away, Winslow Homer, courtesy of The Brooklyn Museum. *Sloop, Bermuda*, Winslow Homer, courtesy of the Metropolitan Museum of Art, New York, purchase, 1910, Amelia B. Lazarus Fund. For Winslow Homer the sea was a constantly inspiring subject. These are two of his many watercolors done on sailing vessels.

Below, two improvised half-sheet watercolors are part of a series of more than twenty-five paintings done on sailing. This pair featured early-evening activity.

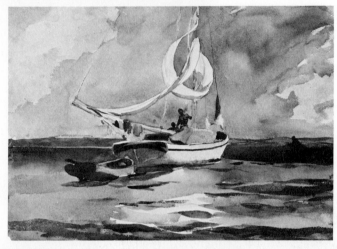

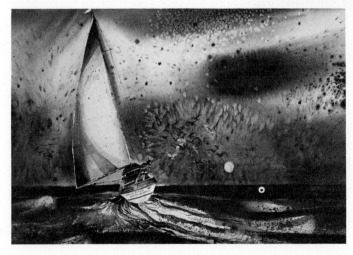

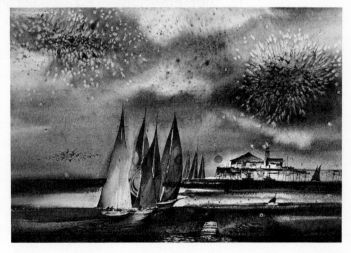

Expressing Feelings and Ideas

Middle Blue, No. 5, Sam Francis, University Art Museum, University of California, Berkeley: Gift of Julian J. and Joachim Jean Aberbach, New York City. The energetic spattered lines in much of Sam Francis' work give an emotional impact to his paintings. Forceful shapes, strong contrasts in value, and spirited textures are some of the stressed elements.

Utilizing our Emotions

Our feelings and ideas are energized by the emotional strength we attach to them. Feeling strongly about a subject or idea brings it into sharp focus. Great artists have the capacity to feel deeply about the content of their work. They often rely on emotional responses to assist in galvanizing ideas and vitalizing work.

The prospect of using our emotions in paintings may strike some as an unnerving undertaking or something to be avoided lest the emotions get out of hand. Emotions, however, can be great catalysts for creating power in our work. To feel intensely is to charge our creative energies and purposes. As we enlarge our capacities, we should avail ourselves of the reinforcement of our emotional responses as we work. This may seem difficult to those who are analytically oriented, but allowing our feelings to come into play will eventually be seen as a positive support for the more controlled intellectual approach.

How does one respond emotionally to subject matter or ideas? A dramatic sunset may reach us on a feeling level, whereas a stand of trees could seem emotionally bland. How can we become sensitive to commonplace items or events? Perhaps more exposure to those

visual stimuli in our environment that evoke emotional responses will start the process. Hence, the dramatic lighting of early morning or evening hours could evoke moods. A misty morning may trigger more feelings than noontime brightness. Staged lighting on objects or unusual arrangements can call forth emotional responses.

If we paint the dramatic we tend to paint with feeling. After enough experience with the dramatic and the unique, we should be able to instill some of this feeling in ordinary items. Once we start to trust the value of the emotional response, we tend to use it for its intended purpose — to energize all of our faculties. Painting with the emotions engaged will be on a more intuitive level: a sensing of form rather than analytic description.

The brush easily conveys feelings. The grip on the brush, the speed and vigor of movement, our muscular tensions all help to deliver the message. Even physical posture can aid in capturing emotional responses in a painting. Explore a tensed physical position in painting emotionally charged subjects, or conversely be more relaxed in reacting to passive qualities in a subject. This physical response is a

Vertical Rock, space series #12, Nick Brigante. This ink and wash painting elicits a powerful mood by its use of richly fused darks and veritcal movements.

Camp Shakers, Don W. Hendricks. One way to increase dramatic impact is to heighten value contrasts. This work demonstrates not only technical mastery but also the value of staging our subjects for maximum effect.

way of empathizing with the subject, of repeating its nature in your own physical being. Explore vigorous brushing, strokes pushed and pulled, tense and relaxed arm movement.

Use an emotional response to initiate a painting by charging the surface with colors, values, and brush strokes that reflect feeling. Paint at a more fevered pace, moving rapidly over surfaces and treating forms generally. Try to instill the spirit of the subject.

Above all, don't be judgmental about your work during this type of intuitive exploration. Using the emotions involves a risk, and first efforts may seem out of control. With more experience at this approach, you will produce desired results. Emotional response coupled with control is a useful initiator in producing work of vitality.

Developing the Imaginative Viewpoint

The imaginative viewpoint is a valuable assist in developing creative competency. Imagination is kindled when we look for the more unusual aspects of our subjects; when we insert uniqueness of shape, color, texture, or pattern; and when we give freer reign to the use of fantasy. Subject shape can be modified to induce more excitement, or a subject can be given a unique placement or combined with unusual elements. Colors and values can be drastically altered to create a more imaginative mood or startling quality. Details might be either excluded or used in exciting patterns that transcend ordinary description.

The setting for our subject matter can assure more dramatic impact. Placing the center of interest back into distance with eye-catching movements carrying us through intriguing middlegrounds and foregrounds can form an imaginative spatial painting. A close-up view of sections of a still life, a landscape, or a human gives a stimulating viewpoint. Large foreground shapes can be contrasted with more diminutive shapes inside the format.

Paintings can be almost solely concerned with movement, pattern, or surface texture. These can enhance the imaginative aspects of a subject. Figures can be active, grouped, contrasted in size, or adorned with richly colored or patterned attire.

Sketching without resource material is a good way to hone imaginative faculties. Letting images form as one draws, either on a purely fantasy basis or directed toward an actual subject, is productive. Similar playfulness with color, pattern, and texture is helpful. The point is to discover the new by forging new images or altering the old. Out of these explorations should come a willingness and courage to attempt something new and challenging.

The more skillful we become as painters, the more need we have for pushing the imaginative viewpoint to achieve freshness and vitality. Albert Einstein's quote applies here: "Imagination is more important than knowledge."

Yesterday's Woman, Morten E. Solberg, courtesy of the National Academy of Design, New York, New York. The lost and found quality of this intriguing composition of figures in an implied setting invites us to participate imaginatively in the viewing.

In this example of pressing the imaginative viewpoint, wet washes and sponged-out areas carry the message of this engine's and engineer's out-of-control speed.

Grave Assignment, part of a series dealing with assassination. This totally improvised work evolved from a growing concern about violent acts in society. It deals with graveyard imagery and the assignment of a brutalized human form to its resting place.

Visual Imagery and the Personal Statement

What we all hope for in painting is to produce work that belongs to our way of thinking, feeling, and reacting. Some call this style. To be able to make visual statements in our own unique way is the most satisfying aspect of creation. The more you paint, the more an individualized imagery will appear. Much like your handwriting, the way you express yourself in paint will be distinctly yours.

Firm resolve is needed to reflect inner feelings and thoughts in an honest approach. The great temptation is to emulate someone else, presumably better than ourselves. If this is pure mimicry, then it will be at best only second- or third-rate parodying of that artist. As long as we keep personally in tune with our own convictions, then outside influences will benefit our vision and abilities. All art classes, books, films, visual materials and so on should open up the learning and growth process.

If we want to be successful as painters, along with knowing our craft we need to know ourselves and express a personal point of view.

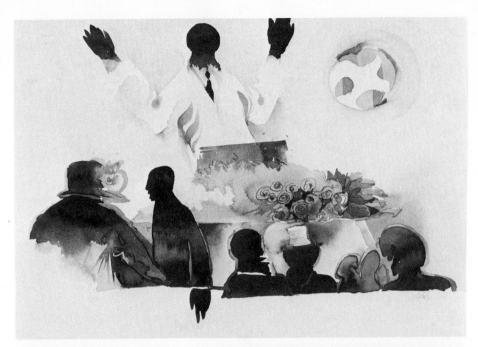

23rd Psalm, part of a series entitled "Psalms, Sermons and Rituals," Bill Pajaud. Direct, simplified imagery gives unusual power to this statement on religious activity.

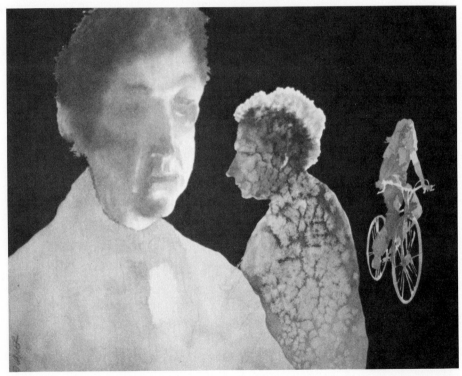

Eighty—Fifty—Eighteen, Lee J. Wexler. Concern with the process of aging is depicted by three striking images.

Sun and Rocks, Charles Burchfield, Albright-Knox Art Gallery, Buffalo, New York. In this work, Charles Burchfield has captured the energy of the landscape and created his own eloquent imagery to deliver the power of his feelings.

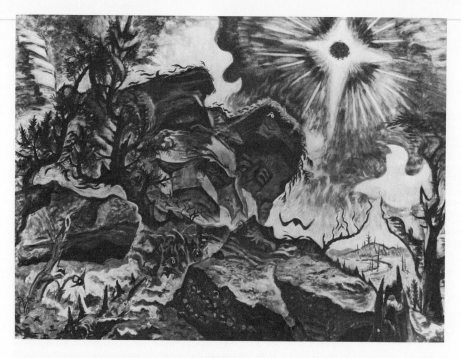

Expression and Risk

A scientist may work on a hypothesis or research project for twenty years only to find it was wrong or misdirected. Usually this person picks up from that conclusion and works toward another solution. Most of us, however, expect our answers immediately or in the not-too-distant future. Expression is not without risk, and failure can be part of the process in reaching success. Watercolor, by its very elusive nature, is a risky medium. It cannot be totally risk-free, nor would one want it to be.

Once risk is accepted as a factor, creative expression has a chance to develop and flourish. This means that some of our work may be glorious failures, but through them we can see where we want to go. One prominent painter felt that if he got eight or nine successful watercolors out of twenty-five, he was doing well. Perhaps he had very high standards, but this willingness to take chances with work produces the real winners.

When we visit an art gallery and see an artist's work we are looking at the successes, what that person selected from a body of work where some of it fell below the quality the artist felt was required. Risk itself is a regenerator. Taking a chance with one's ideas and approaches guarantees growth and creative vision.

As you work, plan for the risk that exciting expression requires — a more exploratory involvement with ideas, with the use of the medium, and with the desire to try the new.

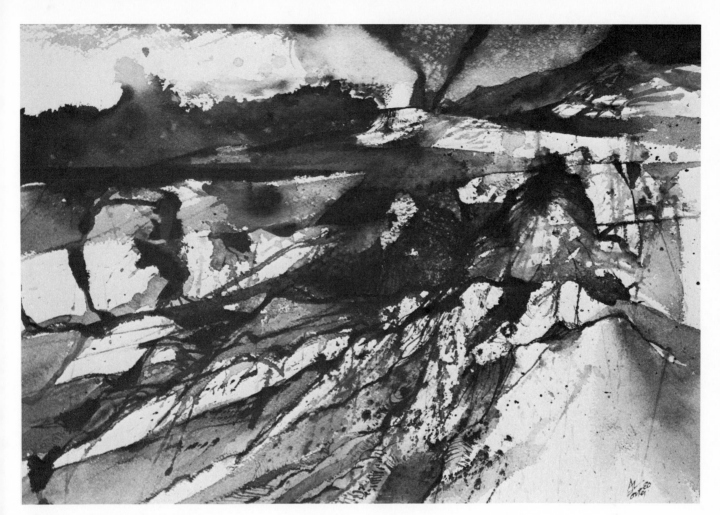

Study for "The Big Show" series.
When your idea or subject requires
expressive force, risk will be involved
in trying to deliver the message. This
study of volcanic activity was part of
a series in which taking chances was
a necessary aspect of the painting pro-
cess.

Summary

On the Way to Market, Bahamas, 1885, Winslow Homer, courtesy of The Brooklyn Museum. Reviewing the work of master watercolorists like Homer, Sargent, and Burchfield is helpful in pointing the way toward effective expression.

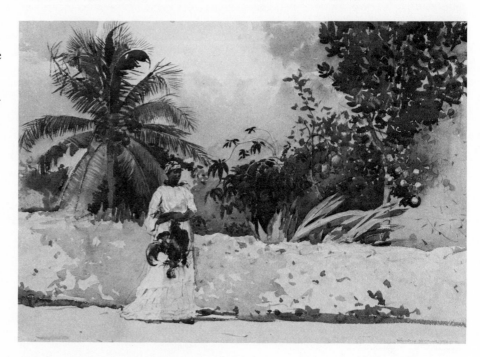

Expressing Ideas with Conviction

This book is filled with the work of convincing painters. They are inner directed, competent with the medium, and totally involved with their expressive approaches.

Our energies need to be focused on developing and expressing our ideas.

If our ideas are thin, then enlarging our insights may require more extensive reading and instruction, visits to art museums and galleries, and taking advantage of meetings with artists. Much can be done independently to develop positive expression. We can develop competence in sketching ideas, become oriented to exploration, and paint on a dedicated basis. As it matures, our experience will assure effective expression.

Mastering the Medium

From the first simple wash studies to the nuances of complex compositions, we are working for a mastery of the medium. This mastery comes out of a long period of struggle, frustration, and plain joy at the successes attained. Work diligently to handle the medium with skill. This means gaining control over wash manipulation,

Tiger, Eugene Delacroix, courtesy of the National Gallery of Art, Washington, D.C., Rosenwald collection. The French painter Eugene Delacroix is well-known for his monumental work in oils. His facility with watercolor, used primarily for sketching, was a significant contribution to the world of watercolor.

New Mexico, Near Taos, 1929, John Marin, courtesy of the Los Angeles County Museum of Art, Mira Hershey Memorial Collection. John Marin brought watercolor into prominence in America. This Southwestern landscape is masterfully executed in his direct expressive manner.

White Cliffs, Joe Mugnaini. The flow of wet watercolor and sharp contrasting whites are combined here to achieve a strong, direct statement on landscape forms.

effective use of color and value, use of texture, brush handling, and combining forms and imagery with finesse.

Practicing with these aspects of the medium until you feel confident is paramount. From these practice sessions should come the knowledge needed to paint any subject matter or idea.

Openness to Discovery There will always be a new way of using watercolor. This medium has already grown from one used almost solely for sketching and minor work to one on the same level as any other. And it is constantly changing as watercolorists explore new ways of using the medium.

As you achieve success in handling the medium, be open to new discoveries. This may mean a deliberate departure from your usual approach. If, as is often recommended, you work from light to dark, try reversing the process and block out areas with frisket to achieve lights. Discovery comes from a concerted desire to find another way. Many of the approaches in this book are directed to opening the door to discovery. It is hoped that once a door is opened, others will be pushed open to reveal yet more possibilities. This enjoyable explanation can go on throughout a lifetime.

Strengthening the Inventive Process

As watercolorists we should be proficient inventors. The imagination needs continual cultivation and exercise; we strengthen it through use. By programming our watercolor activities to stress invention, we will find that our ideas will remain vital and expressive. Our watercolor program should feature periods of imaginative sketching, explorations in more finished work that stress inventive approaches, and the study of watercolorists who are imbued with keenly developed imaginations.

Many of the watercolor societies that are active in the United States offer stimulating exhibitions on an annual or biannual basis. Galleries also support the work of many creative watercolorists, and their shows give us new insights on the inventive process.

Watercolor and invention are ideal partners for producing exciting imagery and work of significance.

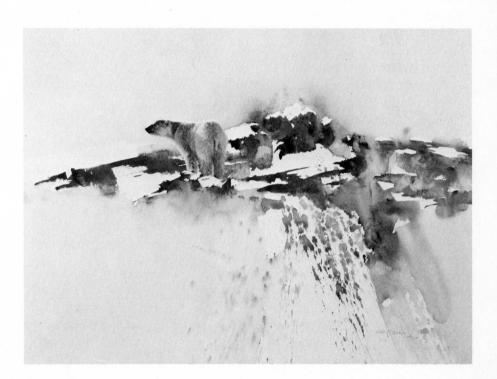

Arctic Monarch, Morten E. Solberg, private collection.

Bibliography

Baigell, Matthew. *Charles Burchfield*. Watson-Guptill, New York, 1976.

Betts, Edward. *Master Class in Watercolor*. Watson-Guptill, New York, 1975.

Brandt, Rex. *The Winning Ways of Watercolor*. Van Nostrand Reinhold, New York, 1973.

Brommer, Gerald F. *Transparent Watercolor: Ideas and Techniques*. Davis Publications, Worcester, Mass., 1973.

Cooper, Mario. *Watercolor by Design*. Watson-Guptill, New York, 1980.

Corn, Wanda M. *The Art of Andrew Wyeth*. New York Graphic Society, Greenwich, Conn., 1973.

Goldsmith, Lawrence C. *Watercolor, Bold and Free*. Watson-Guptill, New York, 1980.

Hoopes, Donelson F. *American Watercolor Painting*. Watson-Guptill, New York, 1977.

———. *Sargent Watercolors*. Watson-Guptill, New York, 1976.

———. *Winslow Homer: Watercolors*. Watson-Guptill, New York, 1976.

Jamison, Philip. *Capturing Nature in Watercolor*. Watson-Guptill, New York, 1980.

Kingman, Dong and Helena. *Dong Kingman Watercolors*. Watson-Guptill, New York, 1980.

Meyer, Susan E. *40 Watercolorists and How They Work*. Watson-Guptill, New York, 1976.

Pike, John. *John Pike Paints Watercolors*. Watson-Guptill, New York, 1978.

Reep, Edward. *The Content of Watercolor*. Van Nostrand Reinhold, New York, 1969.

Reid, Charles. *Figure Painting in Watercolor*. Watson-Guptill, New York, 1972.

———. *Flower Painting in Watercolor*. Watson-Guptill, New York, 1979.

Stebbins, Theodore E. *American Master Drawings and Watercolors*. Harper and Row, New York, 1976.

Wilton, Andrew. *Turner in the British Museum*. British Museum Publications Ltd., London, 1977.

Wood, Robert E. and Nelson, Mary Carroll. *Watercolor Workshop*. Watson-Guptill, New York, 1974.

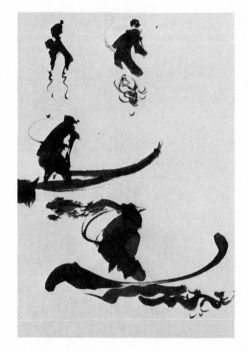

Brush gestures, Bill Pajaud.

Index

Acknowledgments

Although a lot of perspiration went into putting this book together, inspiration was the essential ingredient. That inspiration came from the unselfish assistance of many watercolorists and museums who generously sent examples of their work. I am grateful to the British Museum in London; the National Gallery of Art in Washington, D.C.; The Brooklyn Museum; the Art Institute of Chicago; the Worcester Art Museum in Worcester, Massachusetts; the Whitney Museum of American Art in New York; the Metropolitan Museum of Art, New York; the University Art Museum, University of California, Berkeley; and the Los Angeles County Museum of Art.

I am deeply appreciative of the following artists' superb work and help: Roger Armstrong, Miles Batt, Nick Brigante, Gerald F. Brommer, Dorte Christjansen, Keith Crown, Phil Dike, Joan Foth, Michael Frary, James Fuller, Sylvia Glass, Don W. Hendricks, George James, Win Jones, Mary Jane Keiffer, Joe Mugnaini, Alexander Nepote, Bill Pajaud, Ed Reep, Morten E. Solberg, Paul M. Souza, Ernest Velardi, Lee Weiss, Lee J. Wexler, Jane Wood, Robert E. Wood, and Tom Wooldridge.

I am particularly indebted to Gerald Brommer for making the writing process easier and for his encouragement and direction.

As always, my wife Shirl lent the most important reinforcement when needed.

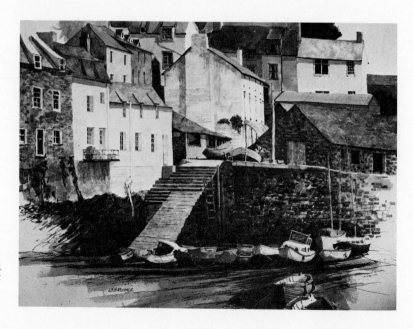

Impression of Cornwall, Gerald F. Brommer. Flat washes are the ideal way to chisel out shapes. This powerful painting uses well-considered wash shapes to form an attractive cluster of houses in England.